The Disasters of War

The Disasters of War

BY

FRANCISCO GOYA Y LUCIENTES

With a new Introduction by Philip Hofer

THE DEPARTMENT OF GRAPHIC ARTS, HARVARD UNIVERSITY LIBRARY

DOVER PUBLICATIONS, INC., NEW YORK

Library of Congress Catalog Card Number: 67-15964

International Standard Book Number
ISBN-13: 978-0-486-21872-4
ISBN-10: 0-486-21872-4

Manufactured in the United States by Courier Corporation
21872420
www.doverpublications.com

This Dover edition, first published in 1967, reproduces in its entirety the first edition of Goya's *Disasters of War* (*Los Desastres de la Guerra*, Madrid, 1863, published by the Real Academia de Nobles Artes de San Fernando): the original Spanish title page and preface and the eighty original plates (natural size).

In addition, the three plates (81–83) which became known only after 1863 are reproduced here from proofs in the collection of the Museum of Fine Arts in Boston.

The present volume also includes a new Introduction by Mr. Philip Hofer, a list of plates, and new translations of the 1863 Spanish title page and preface and of the engraved captions to the plates, prepared by the editorial staff of Dover Publications. (The translation of the captions is, of course, duly indebted to earlier English-language editions.)

Table of Contents

The Disasters of War

Introduction to the Dover Edition

Ever since the 1914–18 war, and its aftermath of "man's continuing inhumanity to man," ever since the second world conflagration and the ensuing cold war, more and more attention has been attracted to Goya's dramatic graphic representations of a similar subject, which came to be known by the posthumous title, *Los Desastres de la Guerra (The Disasters of War)*. First published in 1863, thirty-five years after the artist's death, it normally consists of eighty aquatint plates, roughly six by eight inches oblong format, with short but vivid captions perhaps composed by Goya's learned friend, Ceán Bermúdez, from the artist's notes. The actual execution of the captions is by still another hand. Yet their purport is quite clear: Goya wished to denounce war by making a telling visual report on the Spanish nationalist insurrection against the French puppet king, Joseph Bonaparte, which began in 1808, and soon developed into the Peninsular War. The French artist Jacques Callot had made a somewhat similar, though smaller, series of prints for more or less the same reason nearly two centuries earlier. This had been published at Paris in 1633, and was titled *Les Misères et les Malheurs de la Guerre*. The influence on Goya both in title and content is unmistakable. But as usual Goya borrowed only the idea. His series was much larger and broader in scope and, naturally, he expressed himself in contemporary, even in avant garde terms. As the writer's Harvard colleague, the distinguished art critic Jakob Rosenberg, once said, "These sharply drawn scenes must be essentially true; for Goya in his art records like a seismograph the deep revolution in philosophic, social, and political concepts that shook the western European world in his time." Somewhat earlier, in the depression year of 1932, a different great art critic, Bernard Berenson, had noticed another fact akin to this. For he remarked after a visit to the Goyas in the Prado Museum, "Here in Goya is the beginning of our modern anarchy."

It is hard to understand why Goya failed to publish the *Desastres* series himself immediately after the war of liberation was over. At that time its impact would have been very great. Doubtless he feared some such form of political reaction from the despotic new Spanish regime of Ferdinand VII as had so seriously endangered him when he published his first set of prints, *Los Caprichos*, in 1799. Probably by 1815 he had already added to the sixty-four reportorial *Desastres* plates the sixteen prints of a fanciful, enigmatic nature which certainly contain veiled attacks on persons, Church, and State, as had all the prints of the *Caprichos* series. Thus it was left for a new generation to bring them out, when the passions of the Napoleonic era had receded. The Royal Academy of San Fernando in Madrid acquired the copperplates in 1862, and in that year printed off a few sets of trial proofs of the plates before retouching, as Goya had done with individual subjects in his own lifetime. Then a year later, in 1863, the Academy issued the prints publicly, with a newly engraved title page, and printed preface, in eight paper-covered, numbered parts, with some retouching to the aquatint backgrounds and even to Goya's etching itself! Occasionally the size of a plate was actually altered. But the 1863 first edition reproduced here is a magnificent series of prints, even if it is not strictly as fresh as the unpublished trial proofs the Academy

had run off (a complete set of which is in the writer's possession), or the powerful and delicate proofs which Goya took off the plates himself while in the process of making them. But these proofs are quite unavailable today.

A word about the individual subjects in the series. The caption on one of Goya's plates (number 44) states boldly, "Yo lo vi" (I saw it), confirmed by "Y esto tambien" (And this too) below the succeeding one. Therefore we believe that many *Desastres* subjects were really seen by him, others depicted from eye witness accounts. The first plate, showing a kneeling figure with the moving title "Tristes presentimientos de lo que ha de acontecer" (Sad presentiments of what must come to pass), while nearly equally realistic, does not show Goya himself, but rather the allegorical figure of suffering humanity, horrified by prophetic vision.

A few scenes are of actual historical record, as is number 7, "Que valor!" (What courage!). It represents Agostina, a brave woman of Saragossa, who manned a cannon after all its staff had fallen during the French siege of that city in July, 1808. Lord Byron saw Agostina at Madrid in 1809, and celebrated her exploit in his poem *Childe Harold*. Also, the English artist David Wilkie painted her portrait in 1829. But it is still Goya who has caught her best in this her moment of glory!

Almost equally impressive is number 15, "Y no hai remedio" (And it can't be helped), which uses, as does number 26, the artist's famous shorthand "invention" of showing only the rifle barrels, instead of the French soldiers themselves, who are about to execute a prisoner. Goya employed essentially this same device, but with the soldiers, in his great (Prado) painting "Los Fusilamientos" (The Executions), and Edouard Manet, much later, adopted it for his large canvas in the Louvre of the "Execution of the Emperor Maximilian" (of Mexico). One cannot conceive of a more fearful indictment of war than these prints and paintings!

One of Goya's (or Bermúdez'?) most powerful titles is attached to print number 18: "Enterrar y callar" (Bury them and keep quiet). Another masterpiece is Plate 69 and its one-word caption, "Nada" (Nothing).* This is not Goya's bitter confession of atheism (he was probably quite religious); rather it probably refers to the vanity of all human concerns in the face of death. "Nada" has been written by the corpse on the tablet in front of its right hand. The rendering is worthy of Rembrandt.

After the scenes of war, come the scenes of famine—of the terrible "Año del Hambre" (year of hunger) in Madrid —from September, 1811 to August, 1812, which cost the lives of over twenty thousand citizens (numbers 48–64). Even in a reproduction "Gracias á la almorta" (Thanks to the millet), number 51, proves the truth of Goya's proud statement that: "In art there is no need for color; I see only light and shade. Give me a crayon, and I will *paint* your portrait." This print has all the subtle hues of poverty and hunger.

Not part of the eighty *Desastres* prints published originally, but clearly intended for the series, because of their size, shape, and allegorical content (like the last plates of the series) are Plates 81 and 82, in Delteil's bibliography of

* The words "Ello dirá" (We shall see) were added by the Academy for the 1863 publication.

Goya's prints.* These plates were not rediscovered till after 1863, by the French artist Lefort, and were only much later offered to the Academy of San Fernando. Plate 81 has been awarded the title "Fiero monstruo" (Proud monster). It shows a great beast, something between a hippopotamus and a huge horse or mule, lying on its side, and devouring a number of naked human beings. What does it signify? No one can tell, since one cannot learn the secrets of, nor psychoanalyze, a great artist dead nearly a century and a half. Is it perhaps "war" itself? Or national greed for territory and people, which has so often caused the cataclysms of the past?

Goya's *Desastres* are, however, on the whole fairly understandable and clear cut. Have we learned the lessons from them? We had better look at this fine publication—and be *sure!*

* Delteil, Loÿs, *Le peintre-graveur illustré*, t. 14–15, *Francisco Goya*, Paris, 1922. The present volume includes reproductions of Plates 81 and 82—the latter titled "Esto es lo verdadero" (This is the truth)—as well as Plate 83, a unique proof (no plate extant) in the print collection of the Boston Museum of Fine Arts, titled "Infame provecho" (Infamous gain).

PHILIP HOFER

Cambridge, Massachusetts
1967

LOS DESASTRES DE LA GUERRA:

Coleccion de ochenta láminas inventadas y grabadas al agua fuerte

POR

DON FRANCISCO GOYA.

Publícala la R.�101 Academia de Nobles Artes de San Fernando.

MADRID.
1863.

THE DISASTERS OF WAR

Collection of eighty plates drawn and etched

BY

FRANCISCO GOYA

Published by the Royal Academy of Fine Arts of San Fernando

&

MADRID
1863

Prefacio a la Primera Edición

El nombre de Goya es bien conocido de todos los amantes de las Artes, y ha volado por España y fuera de ella acompañado de una fama merecida: á pesar de la poca justicia con que generalmente son juzgados los hombres de mérito verdadero por sus contemporáneos, la generacion que concluye, que le conoció y trató en su vigor, la que hoy média su camino, que le alcanzó en sus últimos años, y la que comienza su carrera artística y ha visto sus obras y oido hablar de él á sus padres y á sus maestros, todas unánimes le conceden un honroso lugar en la série larga y brillante de los artistas españoles. Y no debe Goya su nombre y su fama á la circunstancia de haber escaseado tanto los artistas notables en España durante el último tercio del siglo pasado y el primero del presente, no: Goya hubiera conquistado siempre y en cualesquiera circunstancias el renombre que no podia menos de adquirirle su originalidad verdadera, hija de la singular independencia de su carácter: maestro de sí mismo, puede decirse que por sí solo constituyó Escuela, adoptando un modo de ver en artes que nadie tuvo antes que él, que acaso nadie seguirá despues. No se propone la Academia hacer una crítica del génio y de las obras de este hombre singular, que ha sido ya juzgado con algun acierto por propios y estraños; y al publicar una coleccion, hasta ahora inédita, de sus estimadas aguas-fuertes, cumple solo un honroso deber, contribuyendo á dar á conocer cada vez mas las obras características de tan distinguido maestro, y tan digno indivíduo de este cuerpo artístico. La coleccion que él designó con el nombre de Estragos ó Desastres de la Guerra, es sin disputa una de las más notables que en este género produjo Goya: en ella se descubre todo el brio de su fogosa imaginacion, exaltada y sobreescitada por un vivo sentimiento de patriotismo, en aquellos terribles momentos en que una injusta invasion estranjera pretendia humillar el orgullo y altivez característicos

del nombre castellano: ¿qué mucho, pues, que un español, un aragonés y un hombre del carácter duro é independiente de Goya se dejase arrastrar muchas veces hasta la exageracion y la caricatura? En cambio respira esta obra novedad en los asuntos, originalidad en los tipos, fuego en la composicion, valentía y seguridad en la mancha, decision y hasta finura en el dibujo. Para que nada falte á esta singular coleccion, las leyendas puestas á cada lámina son otro rasgo mas del génio de su autor: concisas, incisivas y picantes añaden carácter, si añadírselo es posible á lo que ya consignó el lápiz del artista: una breve frase, y á veces una palabra sola, revelan con su misma rapidez la idea fugaz que su mente concibiera en un momento y su mano representara en poco más de otro. La Academia, que ha adquirido las planchas de esta coleccion, conocida de muy pocos y de la que solo se habian sacado un número reducido de pruebas, la publica con la confianza de que ha de merecer una favorable acogida á los amantes de las Artes españolas.

Varias son las biografias que se han escrito y publicado del célebre Goya, cuya vida y cuyo retrato son ya bastante conocidos; por eso la Academia no cree necesario poner al frente de esta publicacion sino una brevísima noticia de su vida y obras, para conocimiento de aquellos pocos que antes de examinarla, no hayan leido ninguna de aquellas.

D. Francisco Goya y Lucientes nació en Fuentedetodos, Aragon, el dia 31 de Marzo de 1746: no se tienen noticias detalladas de su juventud, y solo se sabe que desde la edad de 13 años se dedicó al dibujo en Zaragoza bajo la direccion de D. José Luzan, y que, muy jóven aún, pasó á Roma donde continuó sus estudios. Las primeras obras que dieron a conocer su génio en la pintura fueron los cuadros que ejecutó para la fábrica de tapices,

6

cuyo valor autorizaba con su visto bueno el caballero Mengs, á quien tenia asombrado la grande facilidad con que los hacia. Pintó al fresco una de las medias naranjas de la Iglesia del Pilar de Zaragoza y en Madrid la capilla de San Antonio de la Florida. Tuvo bastante facilidad en los retratos, y los mejores fueron los de aquellos amigos en que no empleó mas que una sesion. El Cristo y cuadro del Santo en la Iglesia de San Francisco, y el de San José de Calasanz en la de San Antonio Abad de Madrid, los tres que hizo para la capilla del Monte Torrero en Zaragoza, el prendimiento que existe en la sacristía de la Catedral de Toledo, y Santa Justa y Rufina en la de Sevilla, bastan para dar á conocer su mérito artístico; aunque siempre merecieron su predileccion los cuadros que tenia en su casa, pues, como pintados con libertad segun su génio y para su uso particular, los hizo con el cuchillo de la paleta en lugar del pincel, logrando sin embargo que causen un efecto admirable á proporcionada distancia. Pintó muchos cuadros en que representó con admirable verdad las costumbres del pueblo bajo de Madrid, y otros muchos asuntos variados y caprichosos. Son muy notables y dignas de verse entre sus obras de estros géneros la coleccion de cuadros que posee el Excmo. Sr. Duque de Osuna en su bella quinta de la Alameda, que representan varias escenas populares en figuras de tamaño mayor y mas concluidas que lo que generalmente acostumbraba, los retratos que en considerable número tienen el mismo Sr. Duque y el de Fernan-Nuñez, y la de pinturas al temple que ejecutó sobre los muros de la casa que habitó en las afueras de Madrid, situada en una altura, cerca del camino de la ermita de San Isidro y que hoy pertenece al Sr. D. Segundo Colmenares: los asuntos de pinturas son muy variados; conciliábulos de brujas, riñas, escenas de costumbres y algun asunto mitológico. La Academia posee cuatro cuadros compañeros que representan un auto de fé, una procesion de Semana santa, una corrida de toros en una aldea, y una casa de locos; posee ademas otro que representa la mascarada del entierro de la sardina, de figuras pequeñas como los otros cuatro; otros dos que representan en tamaño natural el uno una mujer tendida y caprichosamente vestida de maja, y el otro otra que pasa por retrato de la actriz conocida por la Tirana, y el retrato del mismo Goya. Las dos anteriores se van á grabar para formar parte de la coleccion de grabados de sus cuadros notables que la Academia se propone publicar.

Grabó al agua fuerte además de la coleccion que hoy se publica otras tres que compondrán mas de doscientos cobres y pasó los últimos años de su vida dibujando constantemente.

Fué nombrado indivíduo de esta Academia en 7 de Mayo de 1780, Director de Pintura en 13 de Setiembre de 1795, quedando como honorario dos años despues. Fué pintor de cámara del Rey Cárlos IV desde Abril de 1789 y el primero de los de esta clase en Octubre de 1799. Falleció en Burdeos á los 84 años de edad el 16 de Abril de 1828.

Preface to the Original Edition

The name of Goya is well known to all lovers of the arts. It has traversed Spain and crossed her borders, accompanied by well-deserved fame. Despite the lack of fairness with which men of true merit are generally judged by their contemporaries, the generation now coming to an end, who knew him and consorted with him in his prime, the generation today at its halfway mark, who knew him in his last years, and the generation beginning its artistic career, who have seen his works and heard their fathers and teachers speak of him: all unanimously give him an honored place in the long and brilliant line of Spanish artists. And Goya does not owe his name and reputation to the fact that there was such a scarcity of noteworthy artists in Spain during the last third of the past century and the first third of the present one—no: Goya at any time and in any circumstances would have won the renown that his true originality, offspring of the singular independence of his character, could not fail to gain for him. Self-taught, he may be said to have founded a school single-handedly, with a mode of artistic vision which no one before him possessed, which perhaps no one after him will attain. It is not the purpose of this Academy to write a critique of the genius and the works of this extraordinary man, who has already been appraised with a degree of accuracy by his countrymen and by foreigners. By making available a hitherto unpublished collection of his esteemed etchings, we are merely fulfilling an honorable duty by helping to make still better known the characteristic works of such a distinguished master and such a worthy member of this artistic body. The collection which he entitled *Ravages* or *Disasters of War* is irrefutably one of the most noteworthy Goya produced in this medium. In it is to be found all the vigor of his fiery imagination, heightened and stimulated by keen patriotic feeling, in those terrible moments when an unjust foreign invasion attempted to crush the pride and arrogance characteristic of the name of Castile. What wonder, then, if a Spaniard, an Aragonese, and a man of Goya's firm and independent character allowed himself to be drawn often toward exaggeration and caricature? In compensation for this, the work offers new themes, original characterizations, vigorous compositions, the sure touch of mastery in the chiaroscuro, decisiveness and even delicacy in the draftsmanship. So that nothing would be lacking in this singular collection, the legends added to each plate are one more facet of their author's genius; concise, incisive and piquant, they add character to the work, if it is possible to add to what the artist's needle has already supplied: a brief phrase, sometimes a single word, reveals in its very terseness the fleeting idea that his mind conceived at one instant and his hand depicted in little more than another. The Academy, having acquired the plates of this collection, which has been known to very few and of which only a small number of proofs have been printed, publishes it with the firm conviction that it will be favorably received by lovers of the Spanish arts.

Several biographies of the famous Goya have been written and published; his life and his features are already sufficiently well known. Therefore, the Academy believes it will be enough to preface this publication with a very brief notice on his life and works, for the information of those few who have read nothing on the subject before approaching the present work.

Francisco Goya y Lucientes was born at Fuentedetodos [Fuendetodos], in Aragon, on March 31 [30], 1746. There

are no detailed records of his youth; all that is known is that from the age of thirteen he applied himself to drawing at Saragossa under the direction of José Luzán and that, still very young, he went on to Rome, where he continued his studies. The first works that made known his genius in painting were the cartoons he executed for the tapestry workshop; their worth was attested by the approval of the esteemed gentleman Mengs, who was awestruck by the great ease with which Goya produced them. He decorated in fresco one of the cupolas of the Church Nuestra Señora del Pilar in Saragossa and the chapel of San Antonio de la Florida in Madrid. He painted portraits with great facility, the best being those portraits of friends which took no more than one sitting. The "Crucifixion" in the Church of San Francisco [el Grande in Madrid] and the "St. Joseph of Calasanz" in the Church of San Antonio Abad in Madrid, the three works he painted for the chapel of Monte Tor-rero in Saragossa, the "Betrayal of Christ" in the sacristy of the Cathedral of Toledo and the "Sts. Justa and Rufina" in the Cathedral of Seville give sufficient evidence of his artistic merit. And yet his favorite paintings were always those he kept at home; executing them in the free play of his genius and for his private use, he painted them with his palette knife instead of the brush. Even so, these paintings are admirably effective when viewed at the proper distance. He painted many canvases in which he depicted with notable verisimilitude the customs of the lower classes in Madrid and many other varied and fanciful themes. Among his works of this type that are outstanding and worth viewing are the paintings in the collection of His Grace the Duke of Osuna at his beautiful villa La Alameda

(Poplar Grove), which represent various popular scenes, with larger and more finished figures than Goya usually painted; the considerable number of portraits in the posses-sion of the same Duke of Osuna and the Duke of Fernan-Nuñez; and the collection of paintings in distemper which Goya executed on the walls of the house he occupied on the outskirts of Madrid on a height near the road to the her-mitage of San Isidro (the house belongs today to Sr. Segundo Colmenares). The subjects of these paintings are very diverse: witches' sabbaths, brawls, genre scenes and some mythological subjects. The Academy possesses four companion pieces representing an auto da fé, a Holy Week procession, a village bullfight and a madhouse. It possesses another representing the masquerade of the burial of the sardine, with small figures as in the other four; two lifesize paintings, one of a woman lying down, fancifully costumed as a *maja*, the other reputed to be a portrait of the actress known as La Tirana; and a self-portrait of the artist. The two lifesize paintings of women will be en-graved and will appear in the collection of engravings after Goya's best paintings to be published by the Academy.

In addition to the collection now being published, the artist produced three other sets of etchings which run to over two hundred plates. He spent the last years of his life drawing constantly.

He was elected to this Academy on May 7, 1780, be-came Director of Painting on September 13, 1795 and Honorary Director two years later. He was court painter to King Charles IV from April 1789 on, being named first among this group in October 1799. He died at Bordeaux at eighty-four [82] years of age on April 16, 1828.

List of Plates

10

77 QUE SE ROMPE LA CUERDA · *Look, the rope is breaking!*

78 SE DEFIENDE BIEN · *He defends himself well.*

79 MURIÓ LA VERDAD · *Truth has died.*

80 SI RESUCITARÁ? · *Will she live again?*

81 FIERO MONSTRUO! · *Proud monster!*

82 ESTO ES LO VERDADERO · *This is the truth.*

83 INFAME PROVECHO · *Infamous gain.*

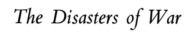

The Disasters of War

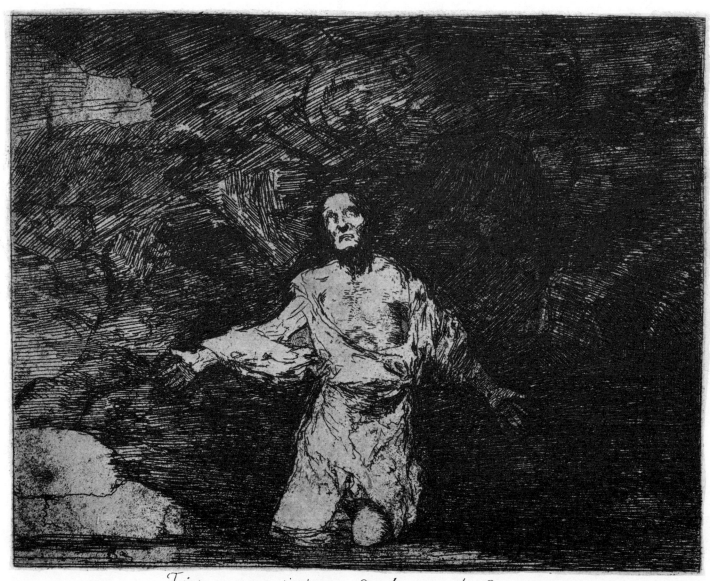

Tristes presentimientos de lo que ha de acontecer.

1 *Sad presentiments of what must come to pass*

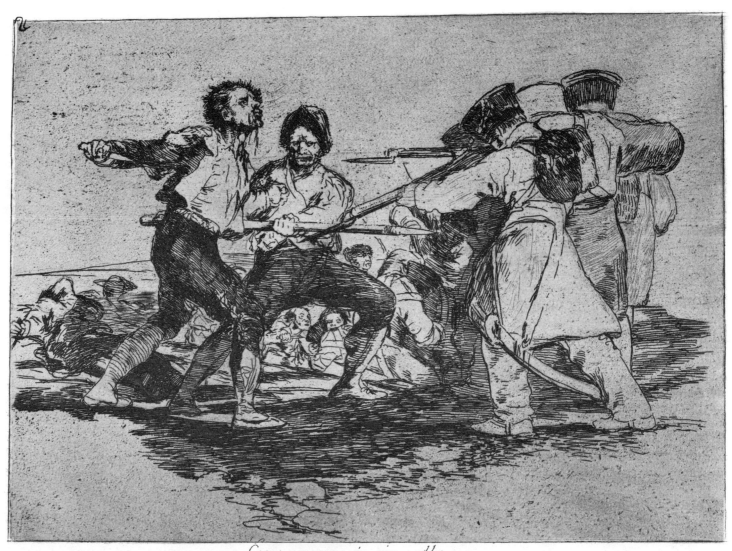

Con razon ó sin ella.

2 *With or without reason*

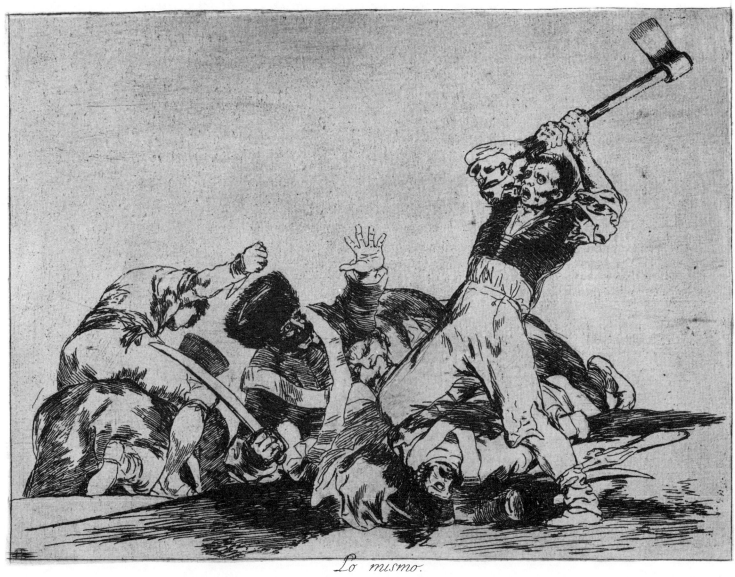

Lo mismo.

3 The same [thing]

4

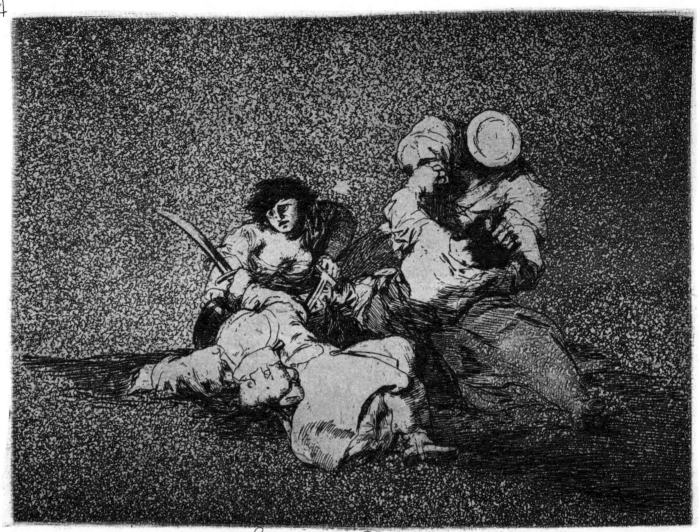

Las mugeres dan valor.

4 **The women give courage**

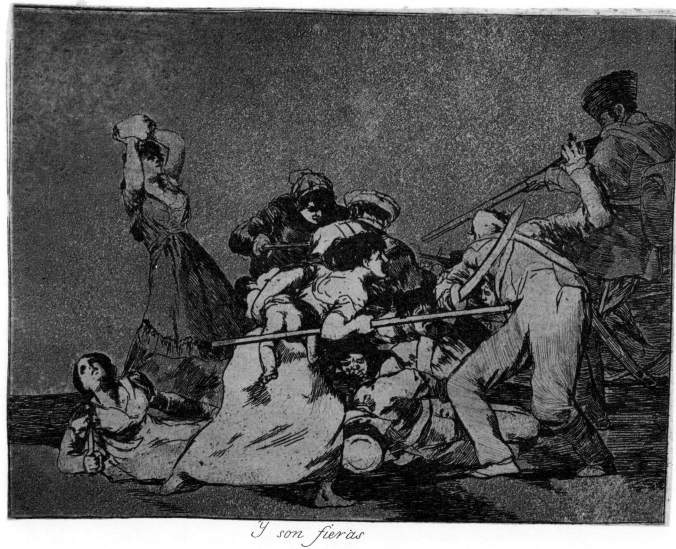

Y son fieras

5 *And are like wild beasts*

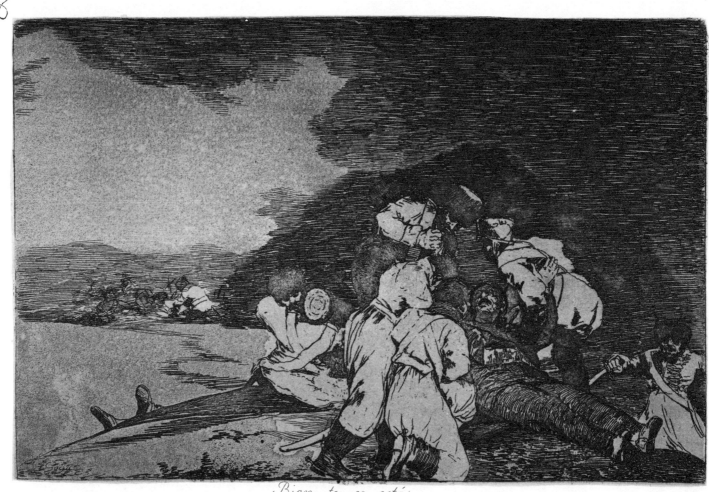

Bien te se está.

6 *It serves you right*

7

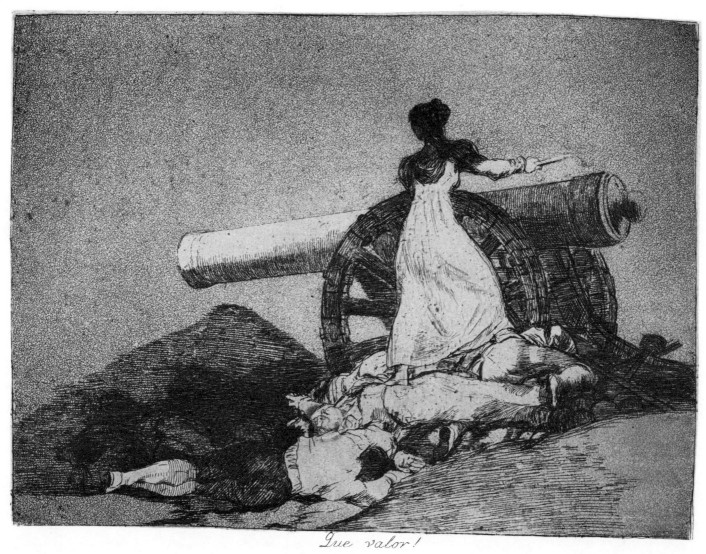

Que valor!

7 *What courage!*

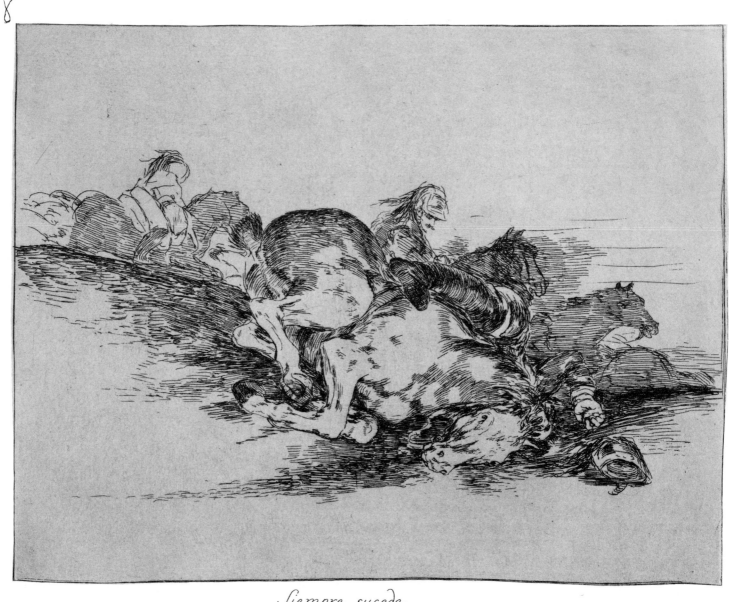

Siempre sucede.

8 **This always happens**

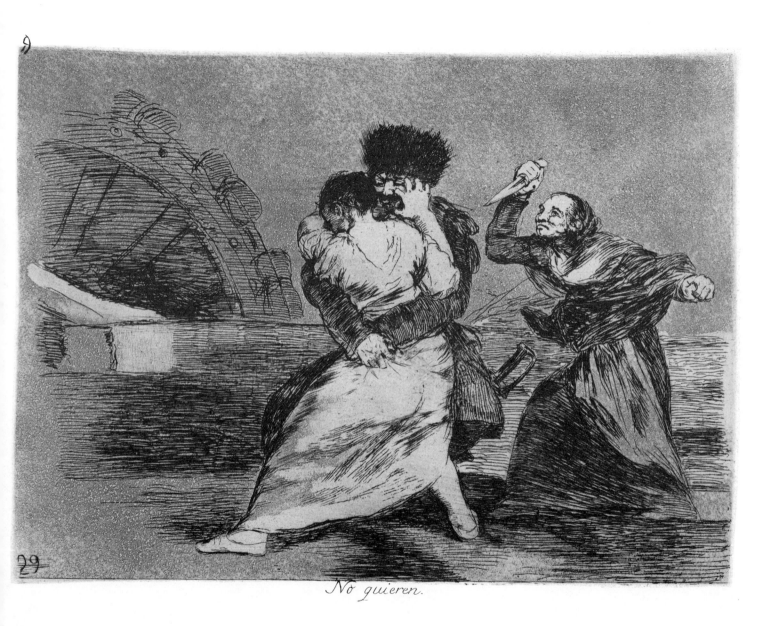

No quieren.

9 **They do not want to**

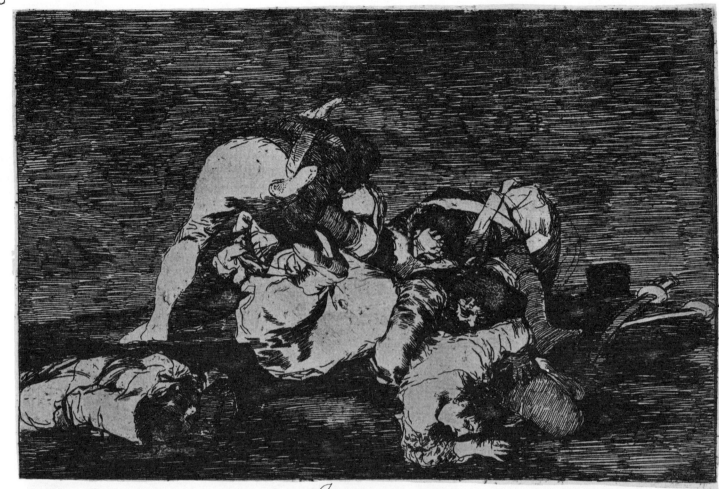

Tampoco

10 Nor do these

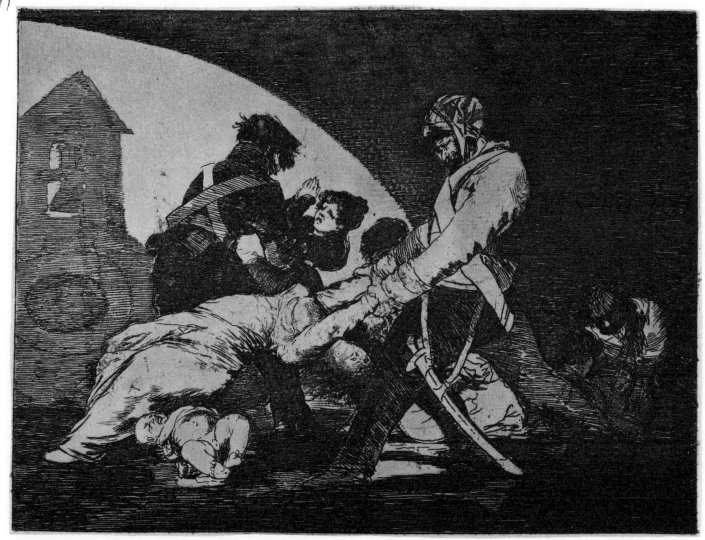

Ni por esas.

11 Or these

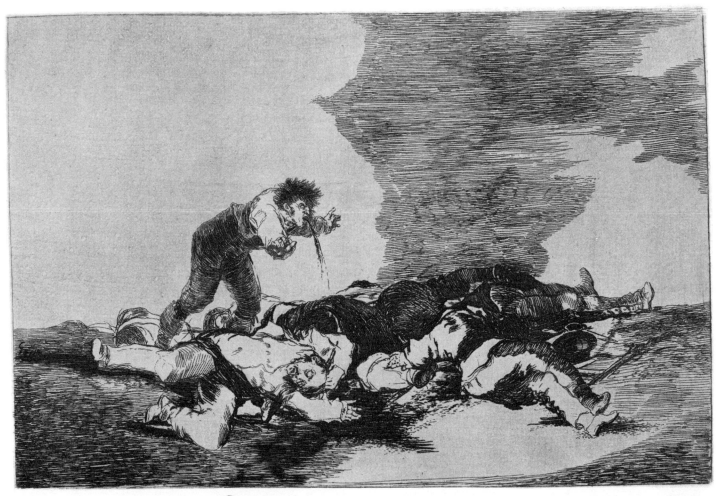

Para eso habeis nacido.

12 *This is what you were born for*

13

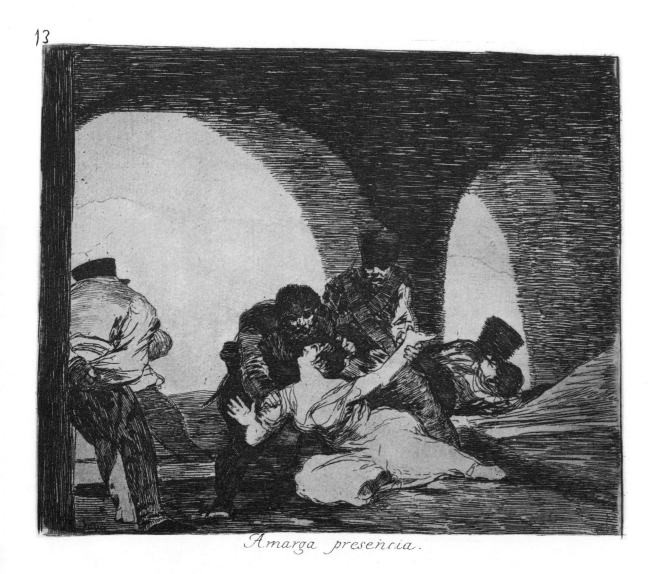

Amarga presencia.

13 Bitter presence

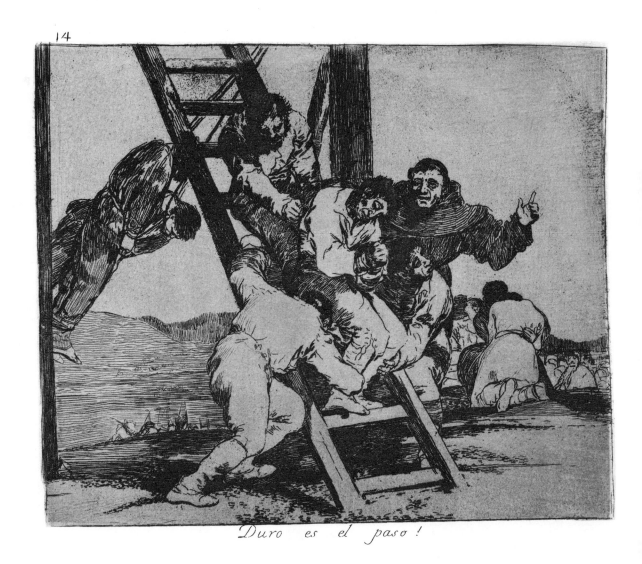

14

Duro es el paso!

14 *The way is hard!*

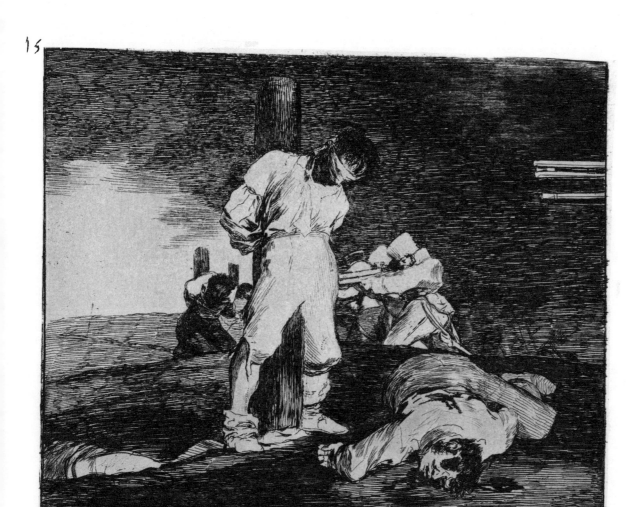

Y no hai remedio.

15 And it can't be helped

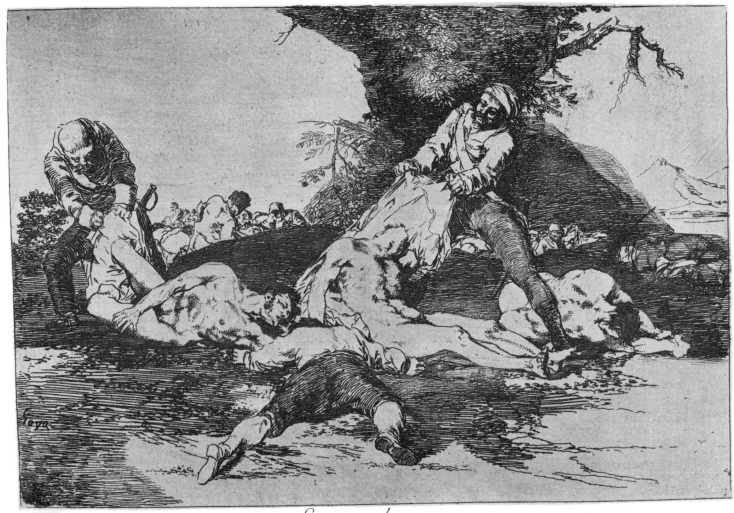

Se aprovechan.

16 They avail themselves

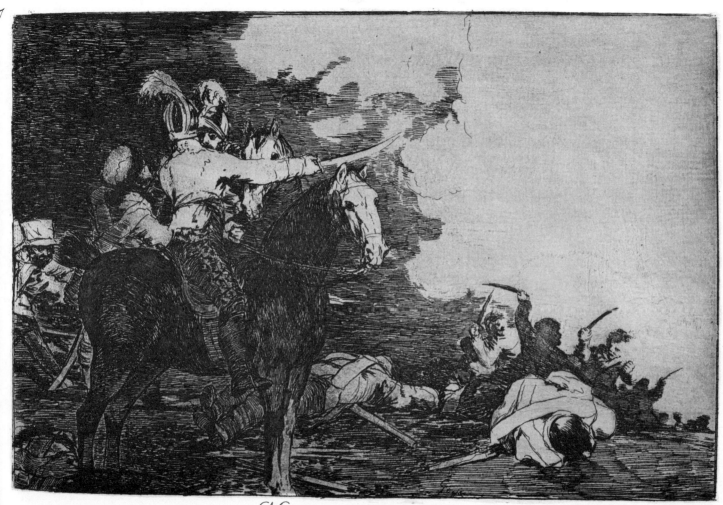

No se convienen.

17 *They do not agree*

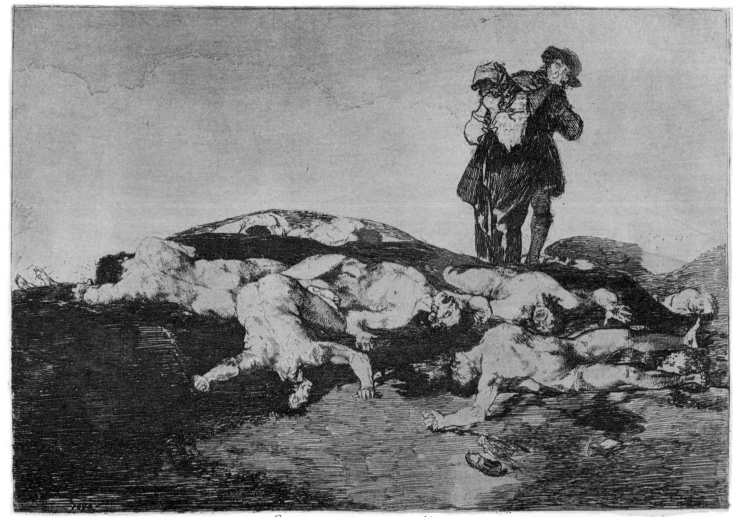

Enterrar y callar.

18 Bury them and keep quiet

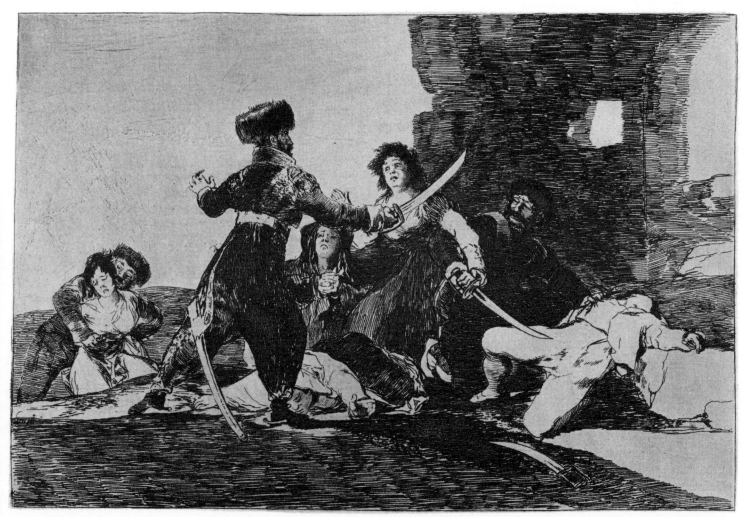

Ya no hay tiempo.

19 There is no more time

20

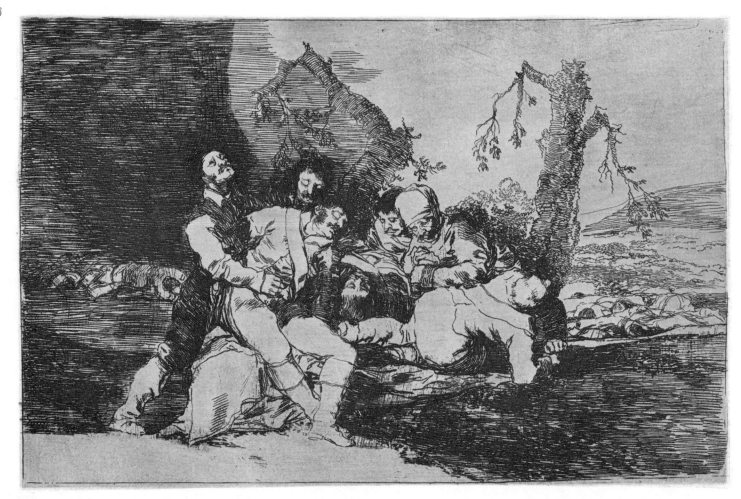

Curarlos, y á otra.

20　**Treat them, then on to other matters**

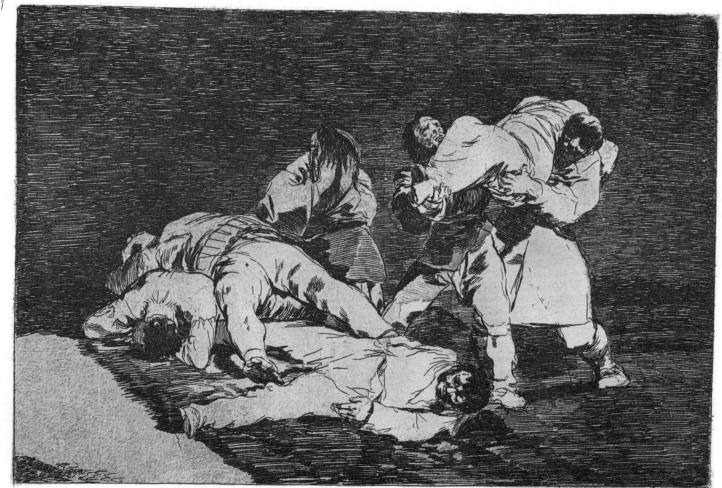

Será lo mismo

21 *It will be the same*

22

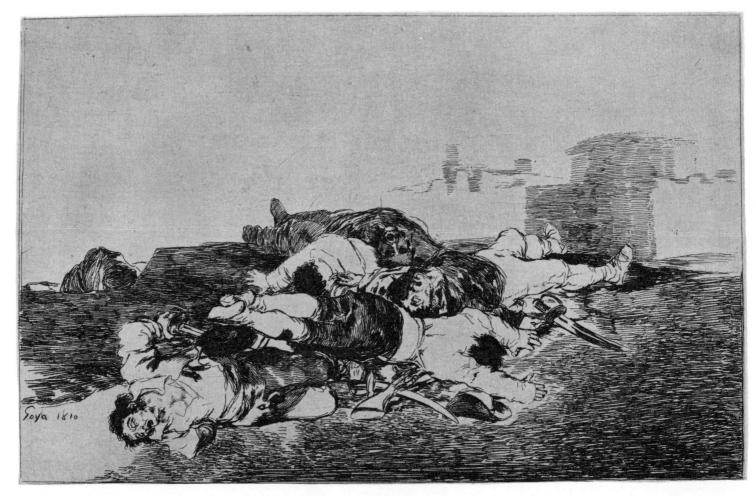

Tanto y mas

22 *All this and more*

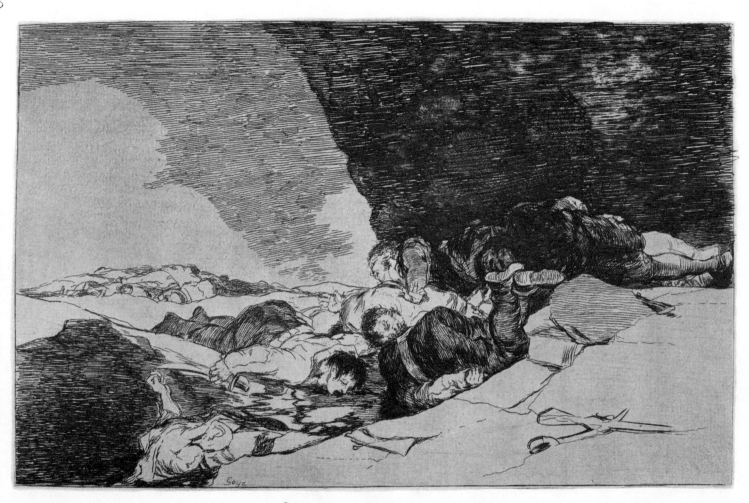

Lo mismo en otras partes

23 *The same [thing] elsewhere*

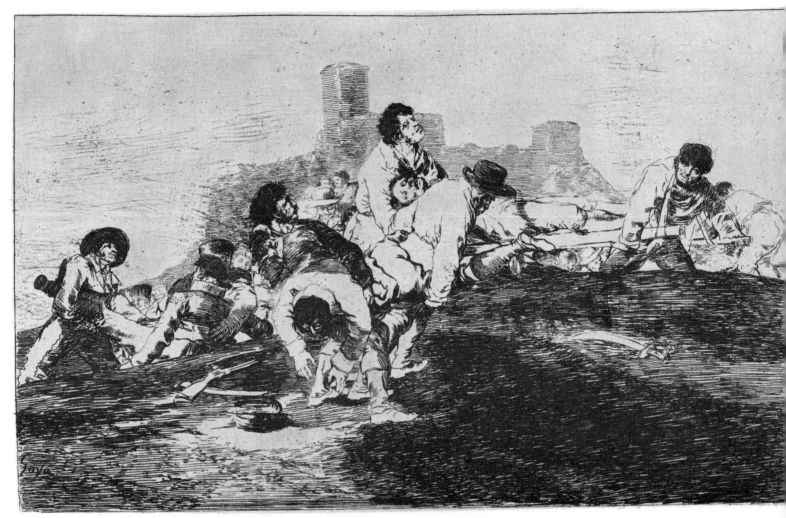

Aun podrán servir

24 They'll still be useful

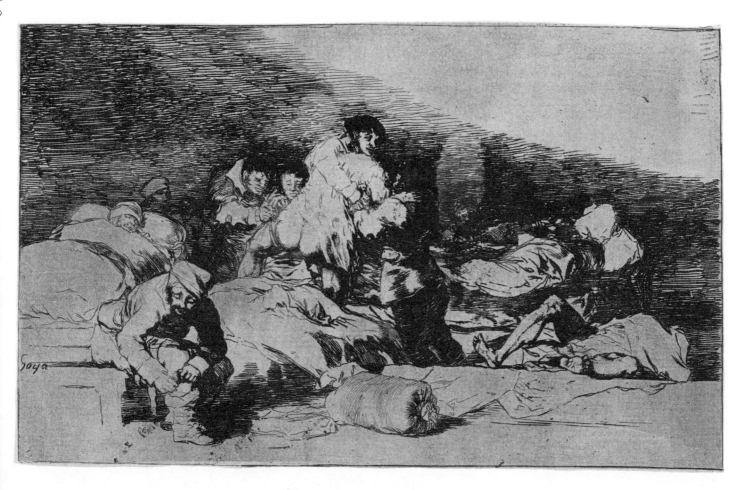

Tambien estos.

25 *So will these*

No se puede mirar.

26 One cannot look at this

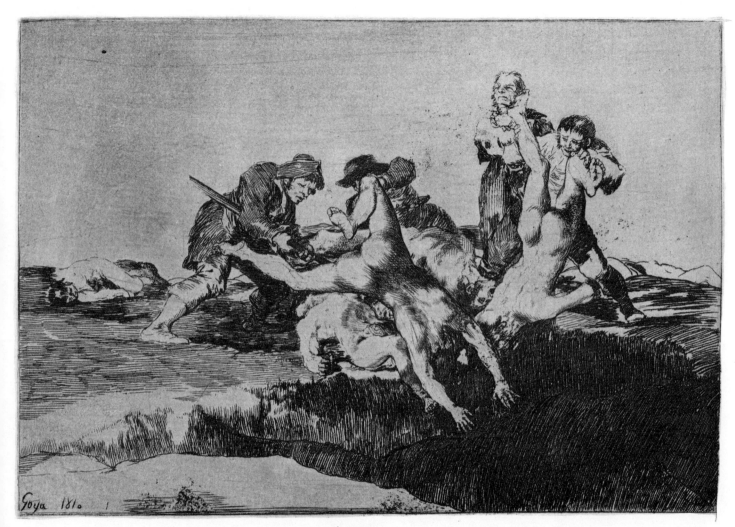

Caridad.

27 Charity

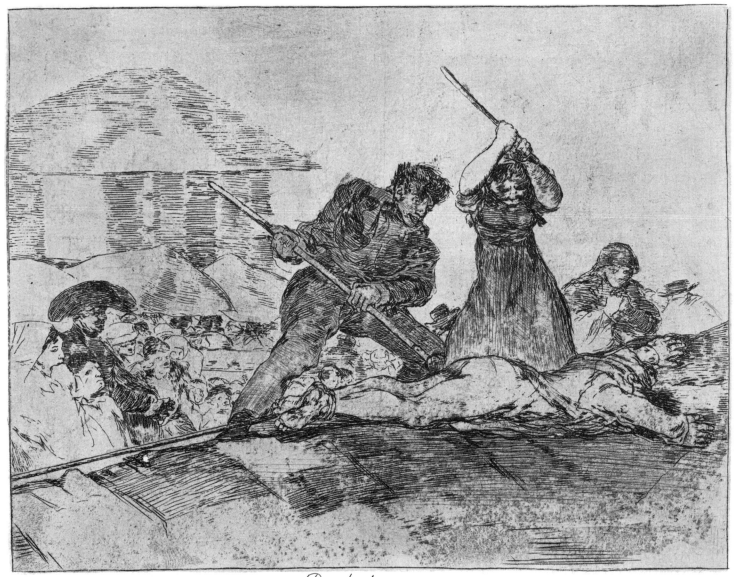

Populacho.

28 Rabble

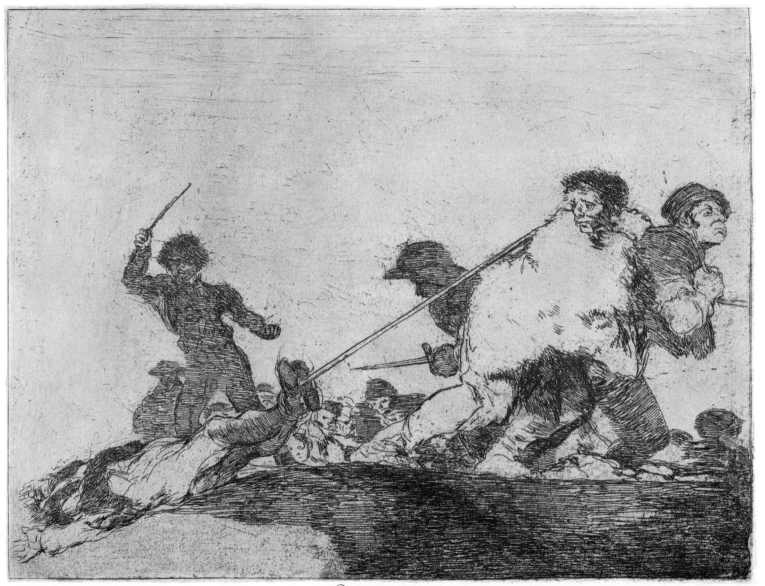

Lo merecia.

29 He deserved it

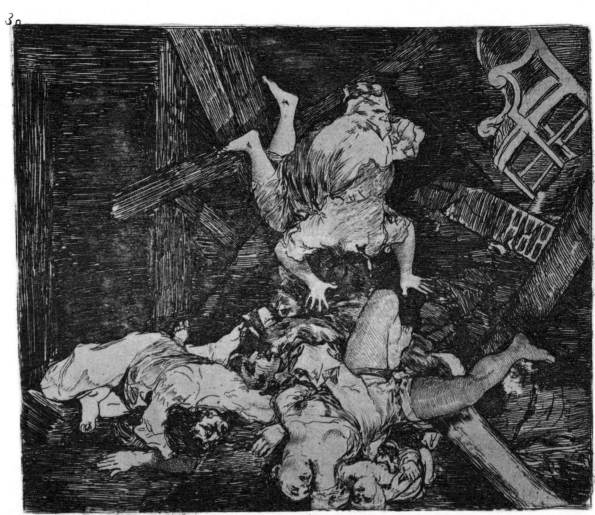

Estragos de la guerra

30 Ravages of war

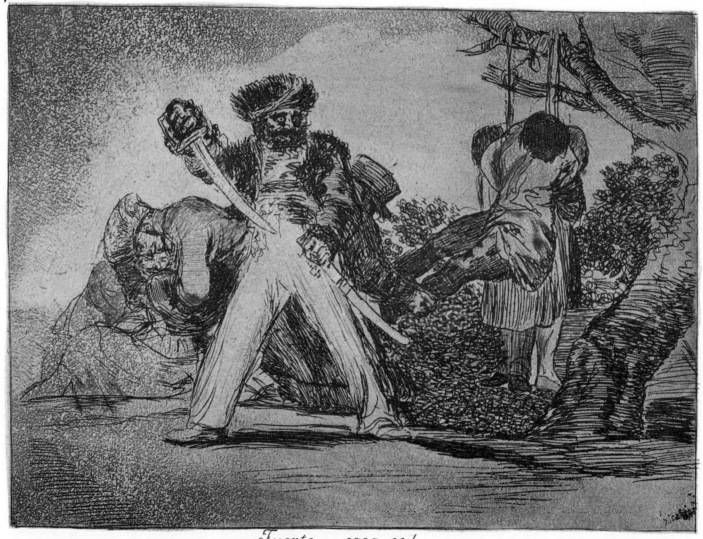

Fuerte cosa es!

31 *This is too much!*

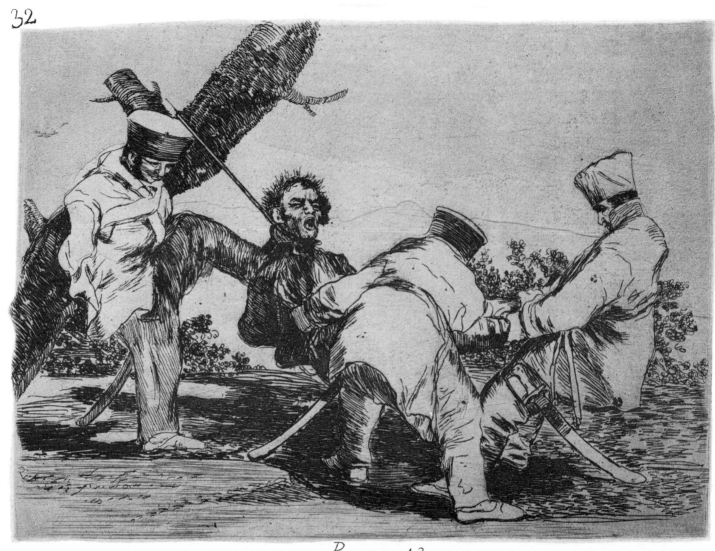

Por qué?

32 Why?

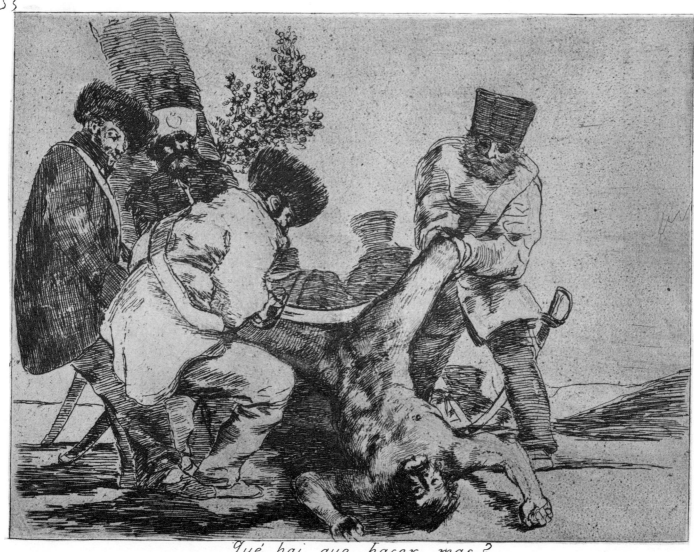

Qué hai que hacer mas?

33 *What more can one do?*

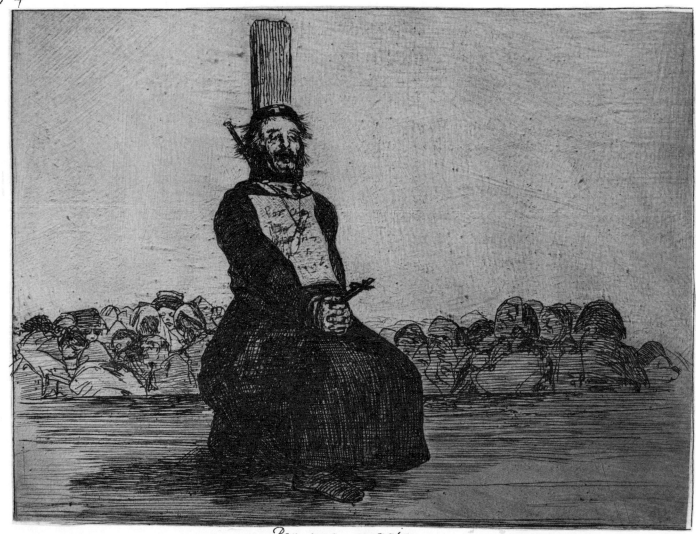

Por una navaja.

34 On account of a knife

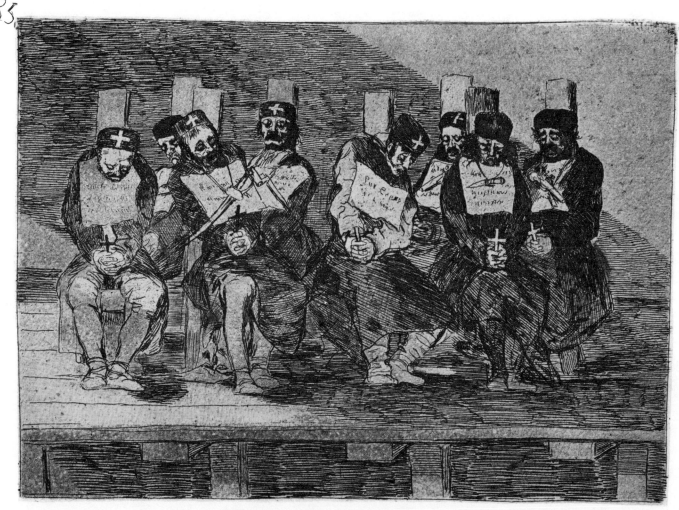

No se puede saber por qué.

35 *Nobody knows why*

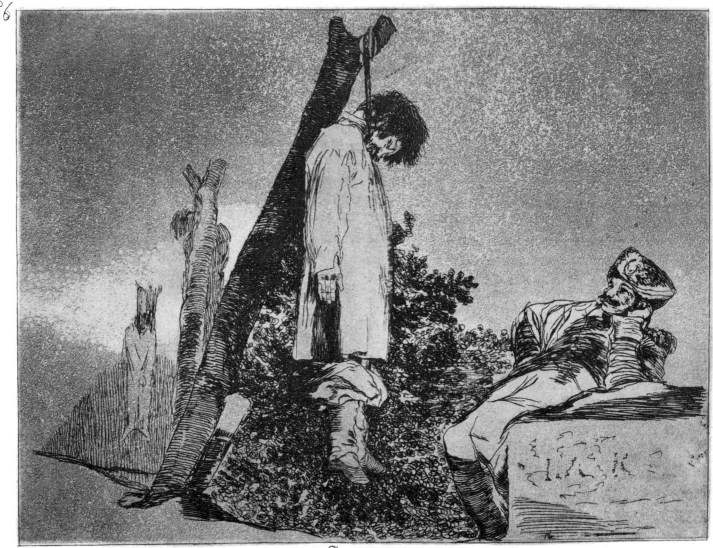

Tampoco.

36 Not [in this case] either

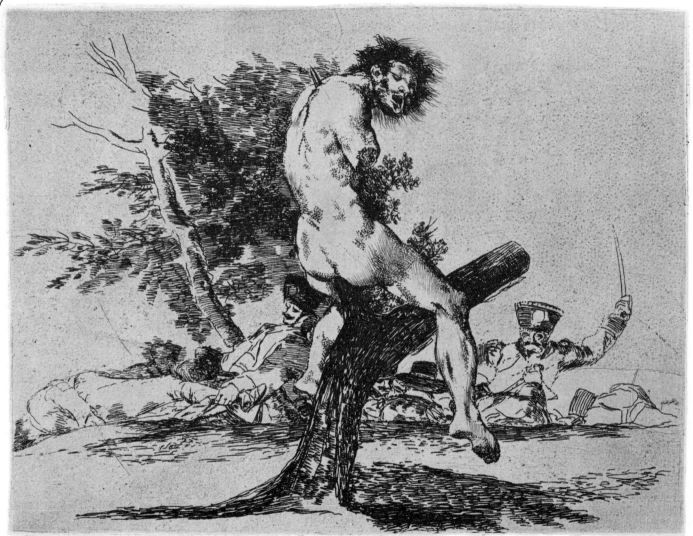

Esto es peor.

37 This is worse

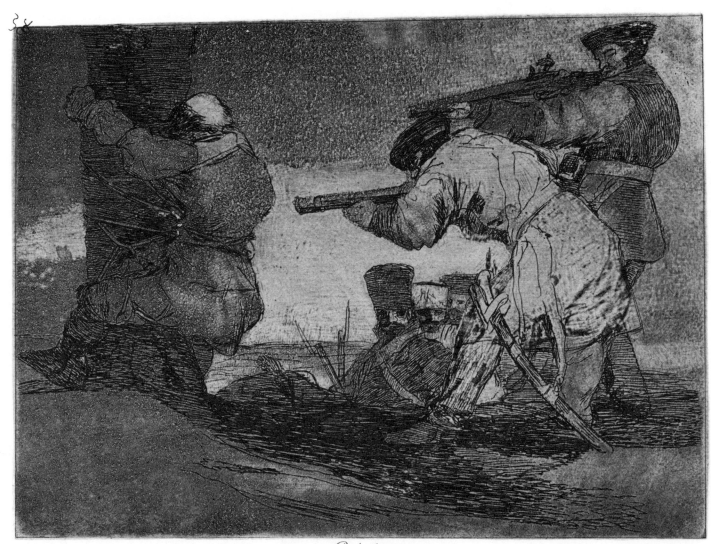

Bárbaros!

38 Barbarians!

39

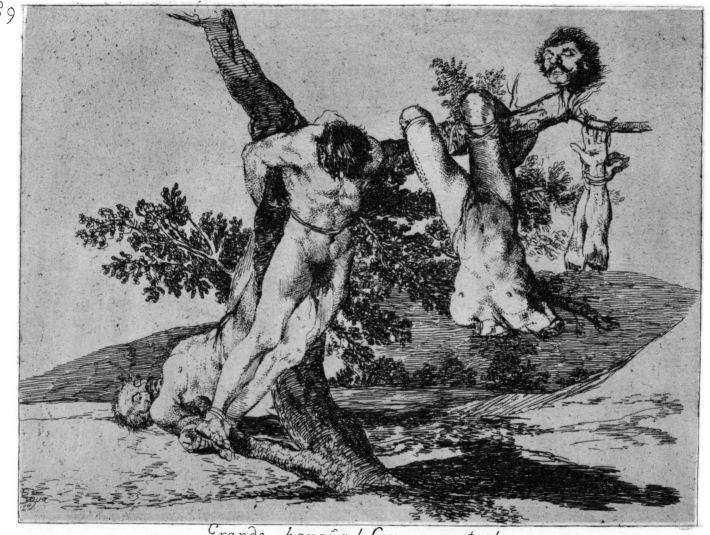

Grande hazaña! Con muertos!

39 *Great deeds—against the dead!*

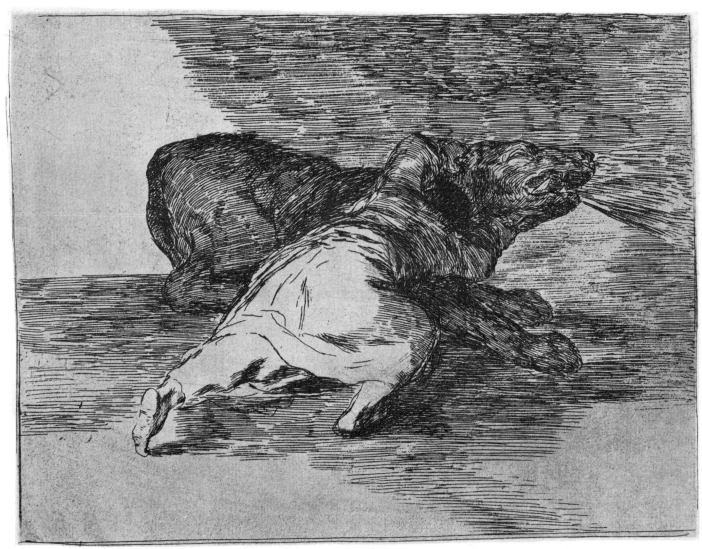

Algun partido saca.

40 There is something to be gained

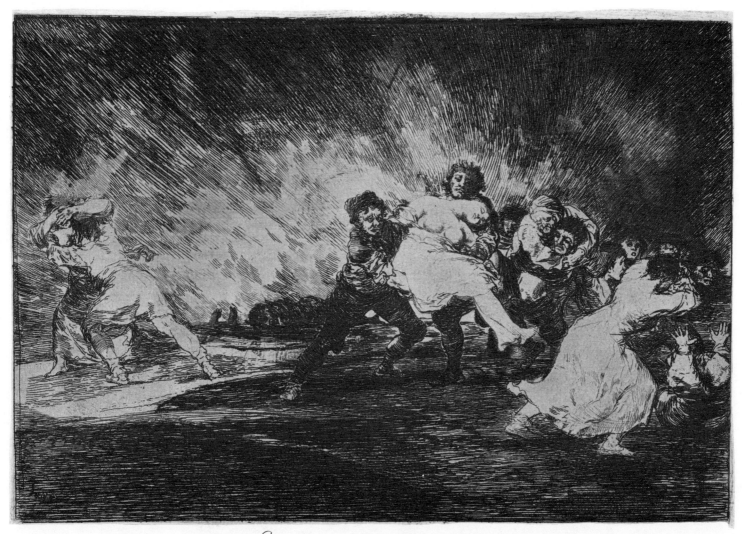

Escapan entre las llamas.

41 *They escape through the flames*

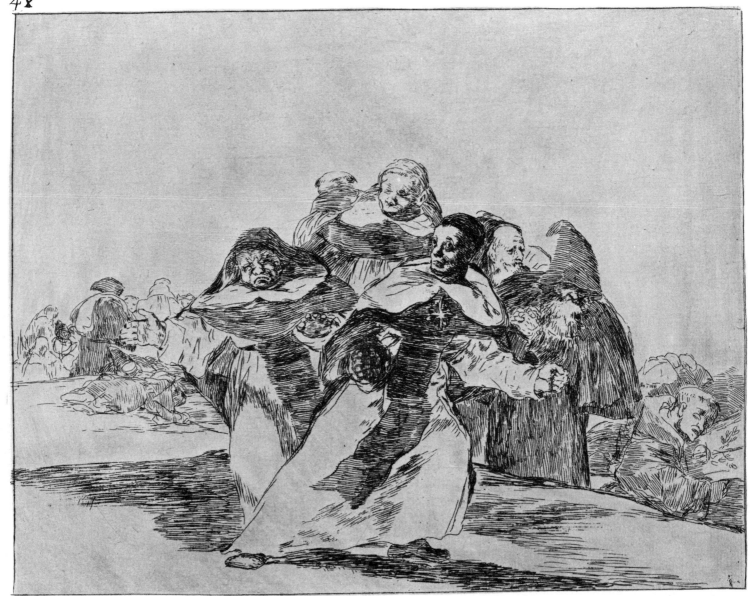

Todo va revuelto.

42 **Everything is topsy-turvy**

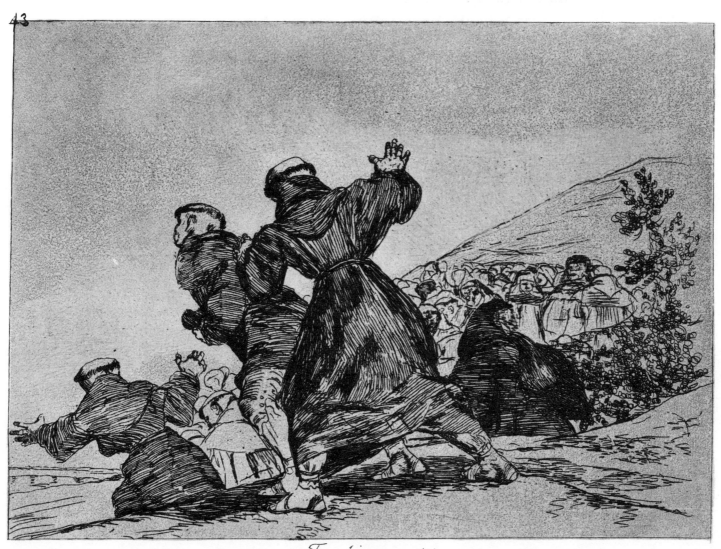

Tambien esto.

43 So is this

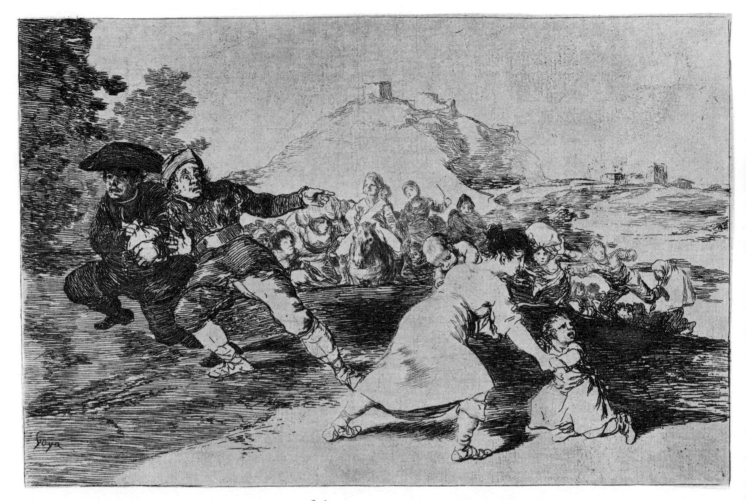

Yo lo vi.

44 I saw it

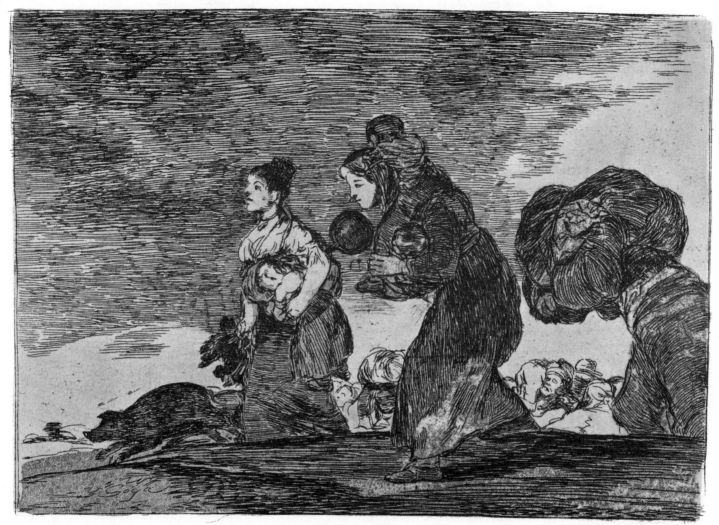

Y esto tambien.

45 **And this too**

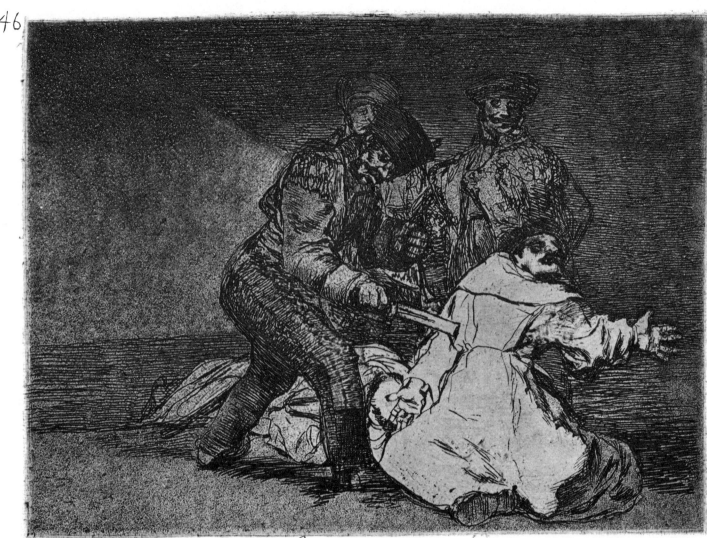

Esto es malo.

46 This is bad

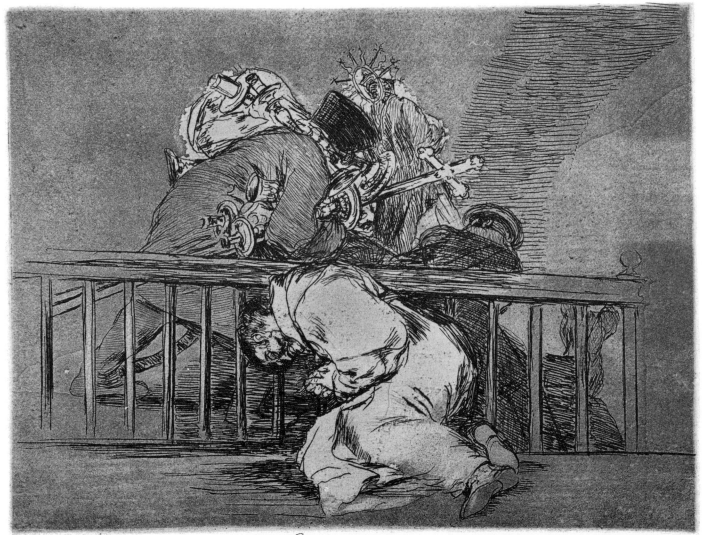

Asi sucedió.

47 This is how it happened

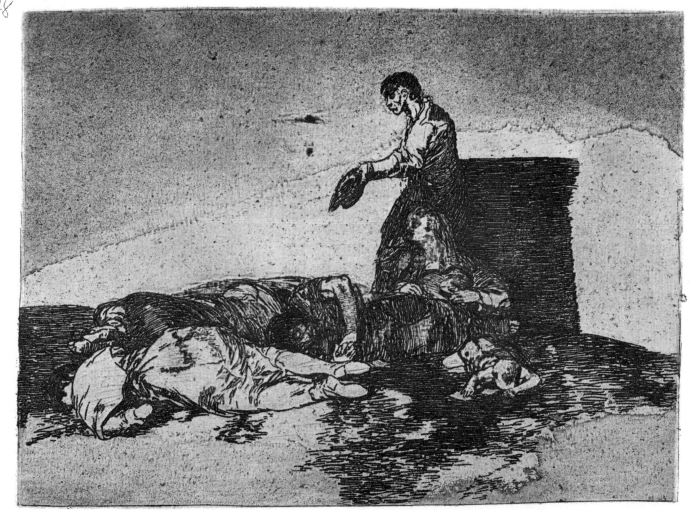

Cruel lástima!

48 *A cruel shame!*

Caridad de una muger.

49 *A woman's charity*

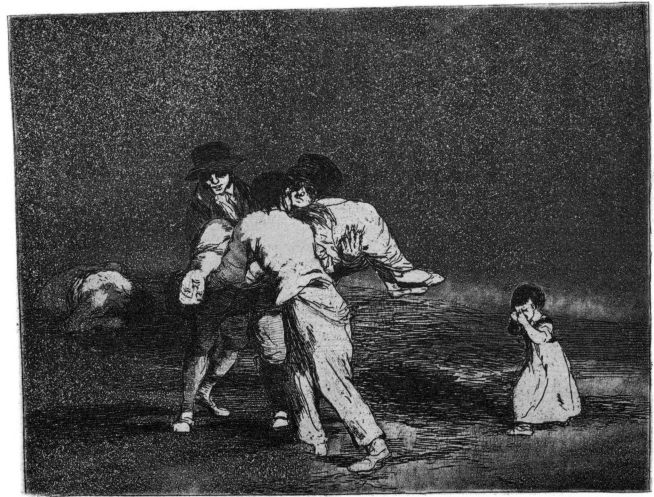

Madre infeliz!

50 *Unhappy mother!*

51

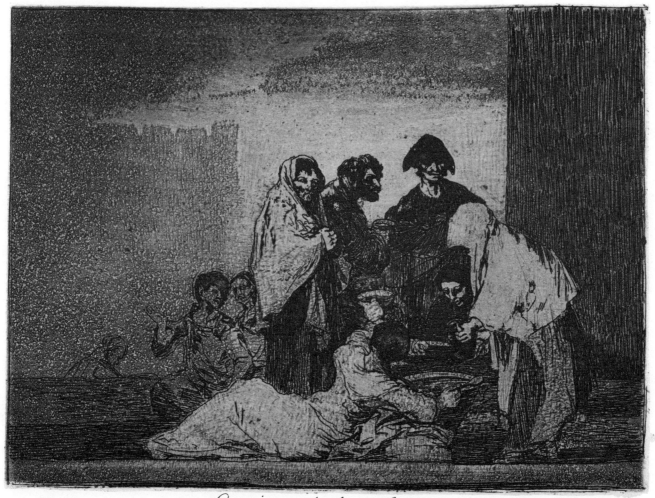

Gracias á la almorta.

51 **Thanks to the millet**

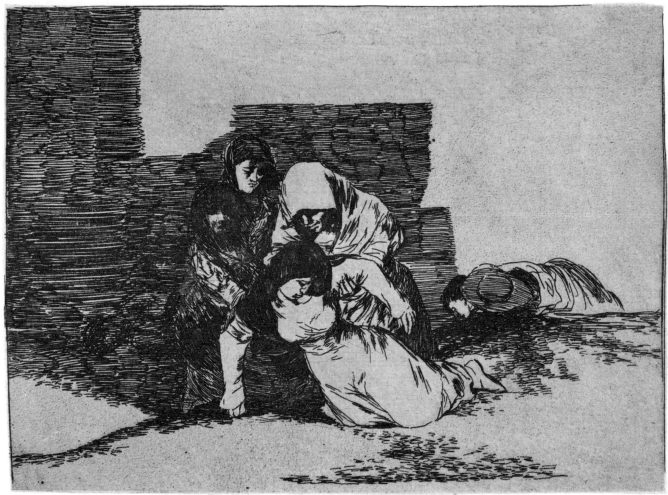

No llegan á tiempo.

52 They do not arrive in time

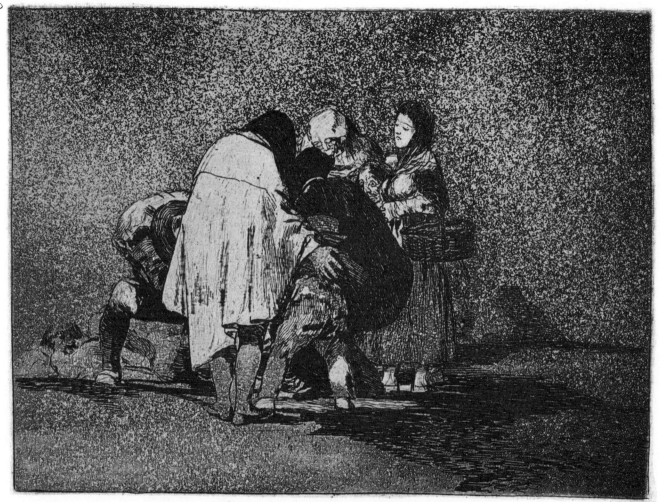

Espiró sin remedio.

53 There was nothing to be done and he died

54

Clamores en vano.

54 Vain laments

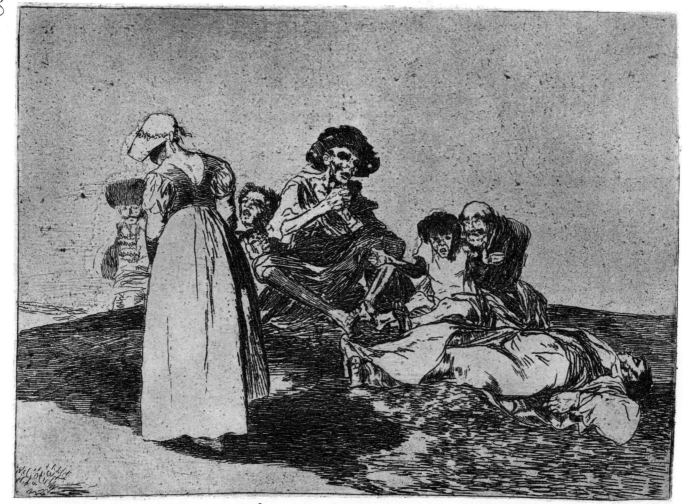

Lo peor es pedir

55 The worst is to beg

56

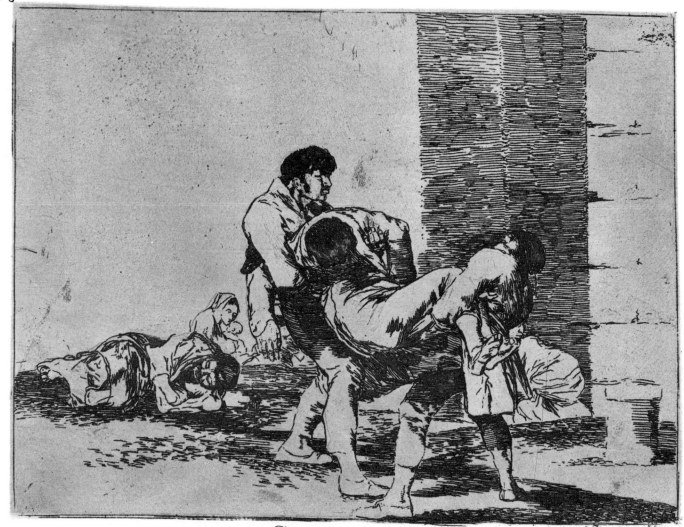

Al cementerio

56 To the cemetery

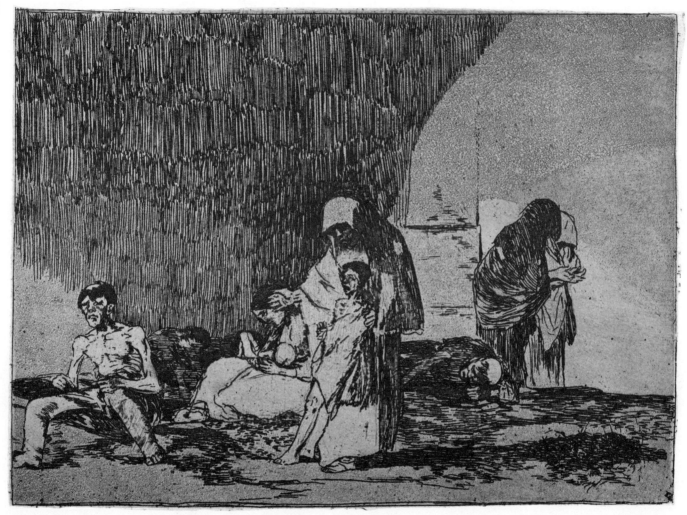

Sanos y ēnfermos

57 The sound and the sick

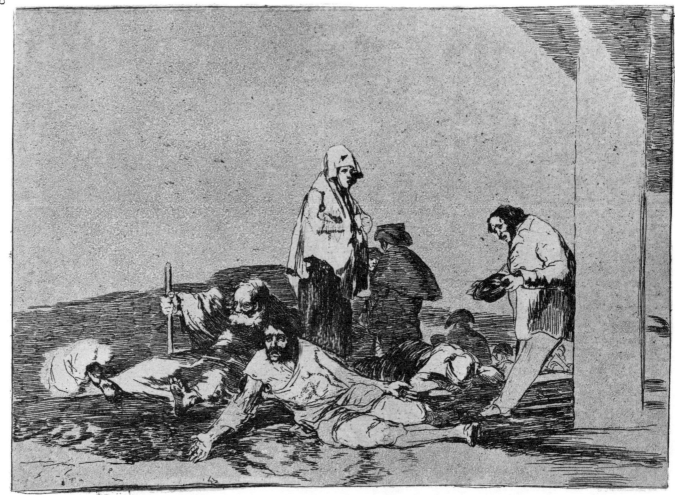

No hay que dar voces.

58 *It is no use shouting*

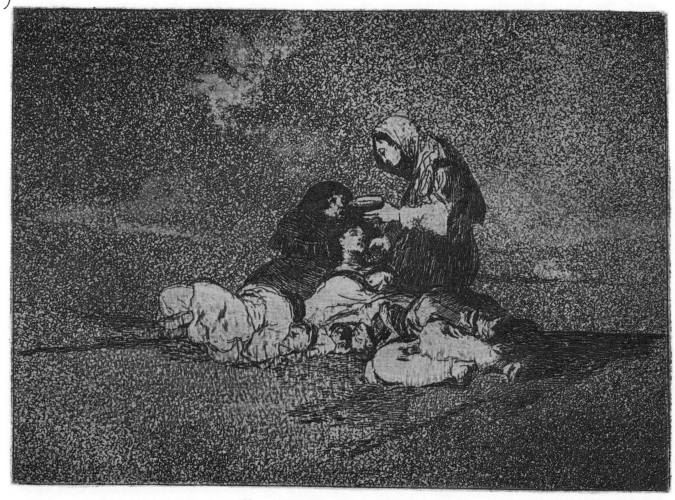

De qué sirve una taza?

59 What good is a single cup?

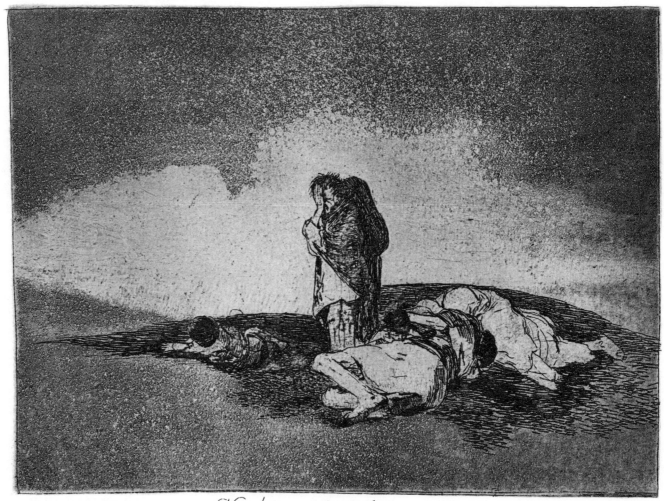

No hay quien los socorra.

60 *There is no one to help them*

61

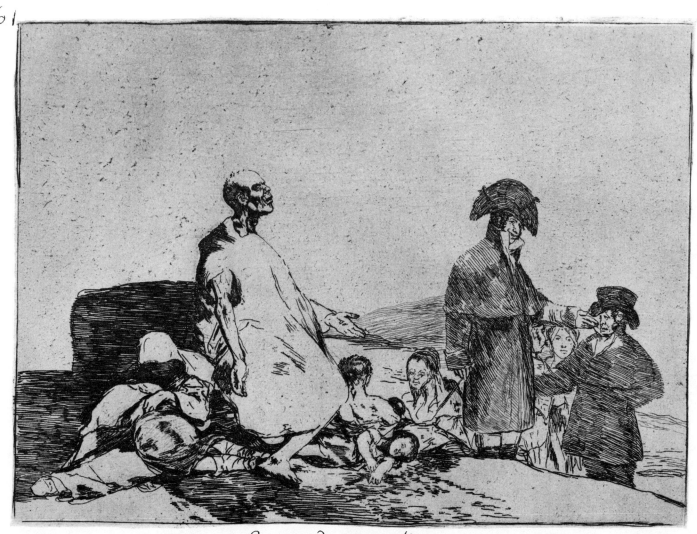

Si son de otro linage.

61 *Perhaps they are of another breed*

62

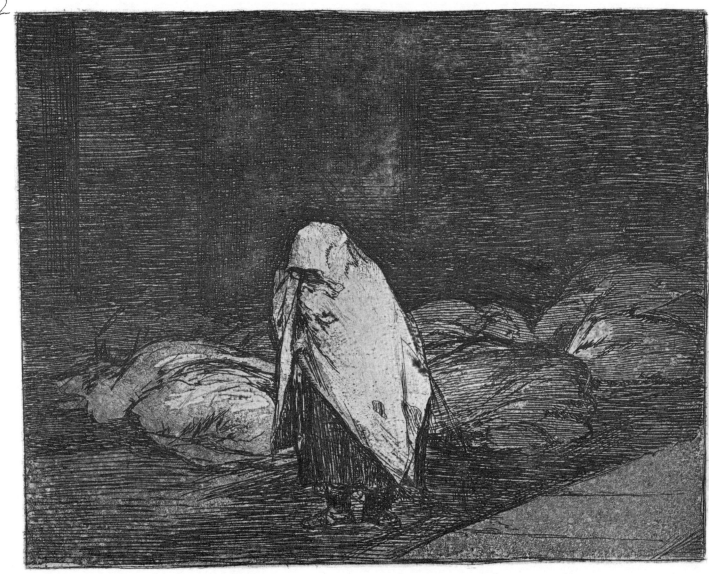

Las camas de la muerte.

62 **The deathbeds**

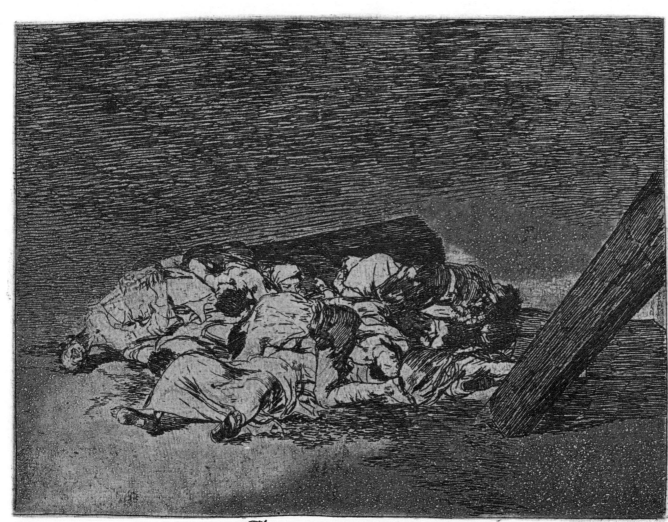

Muertos recogidos.

63 *A collection of dead men*

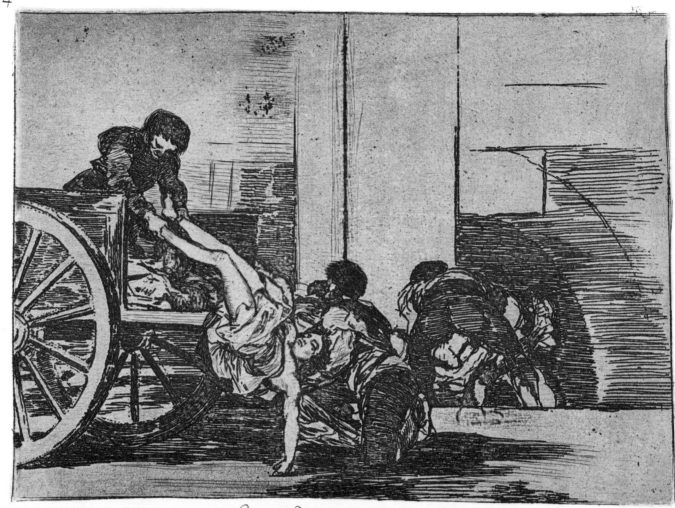

Carretadas al cementerio.

64 Cartloads for the cemetery

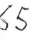

Qué alboroto es este?

65 *What is this hubbub?*

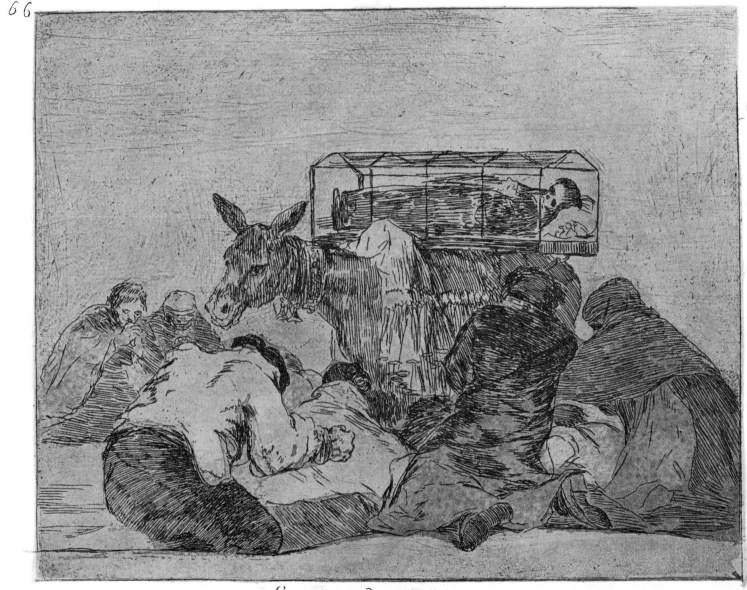

Extraña devocion !

66 *Strange devotion!*

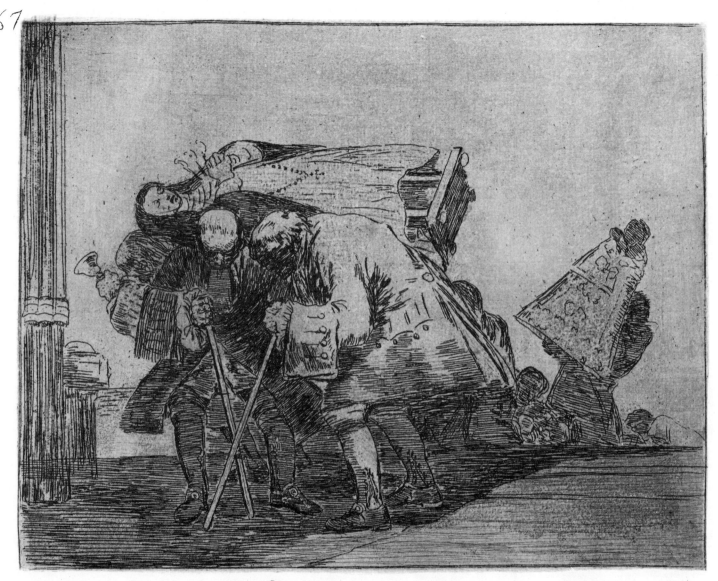

Esta no lo es menos.

67 This is no less curious

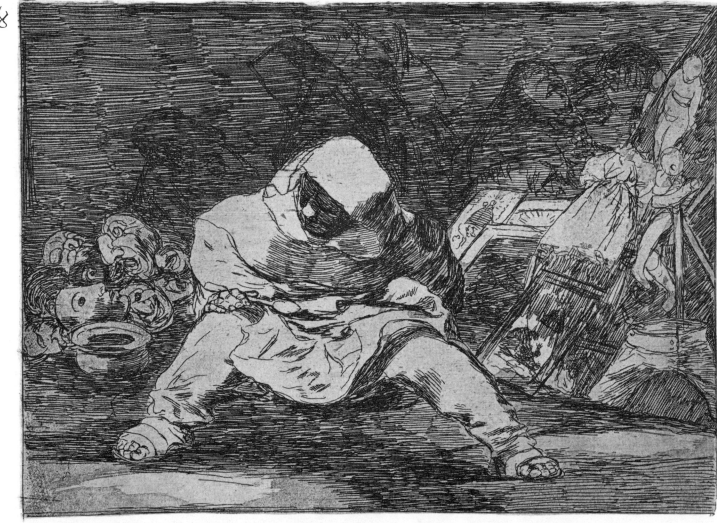

Que locura!

68 *What madness!*

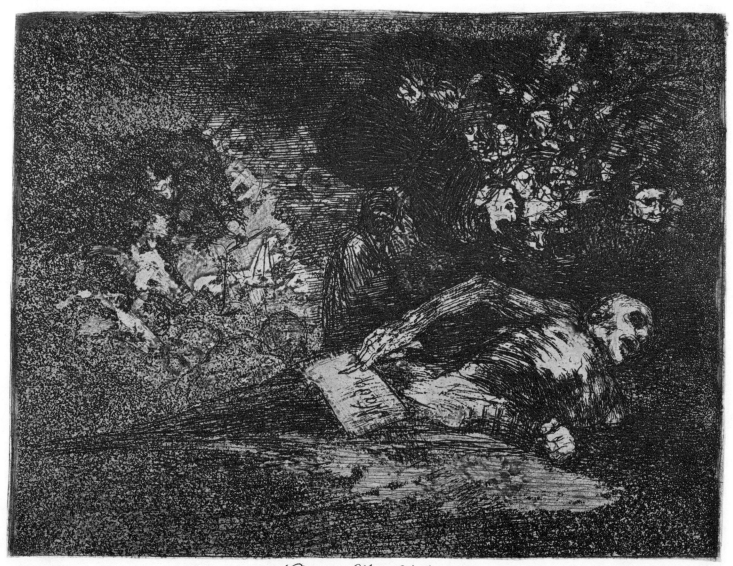

Nada. Ello dirá.

69 Nothing. We shall see.

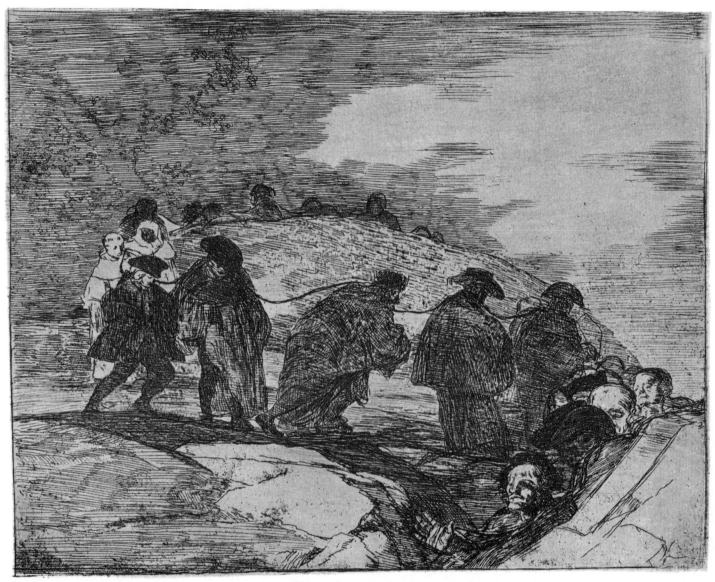

No saben el camino.

70 They don't know the way

11

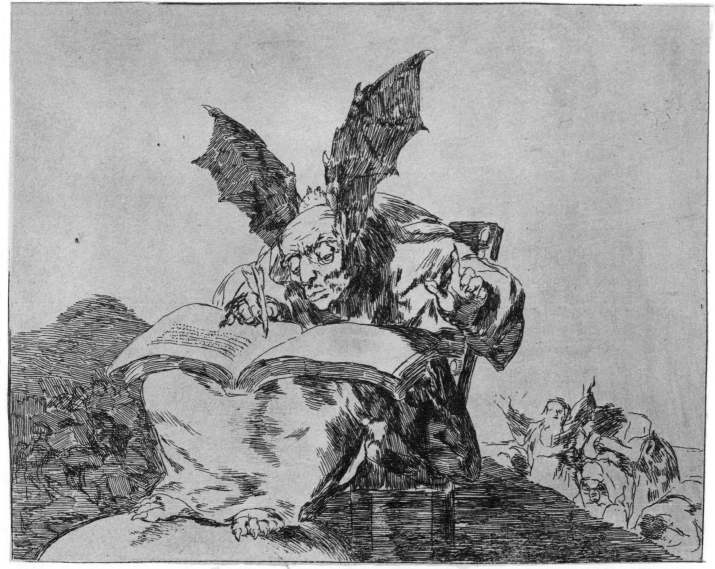

Contra el bien general.

71 *Against the common good*

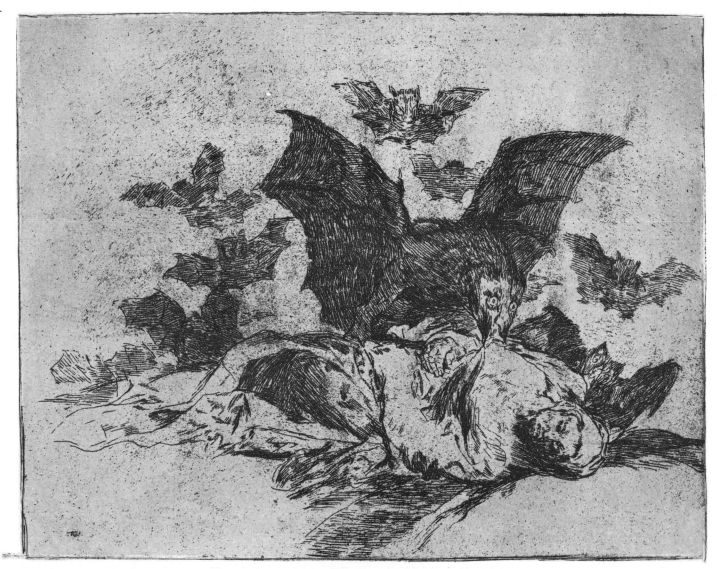

Las resultas.

72 The consequences

73

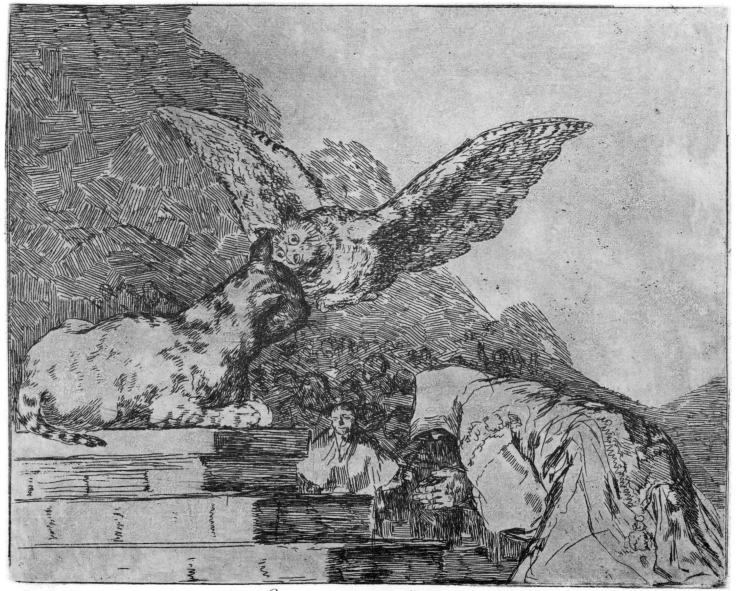

Gatesca pantomima.

73　*Feline pantomine*

Esto es lo peor!

74 This is the [absolute] worst!

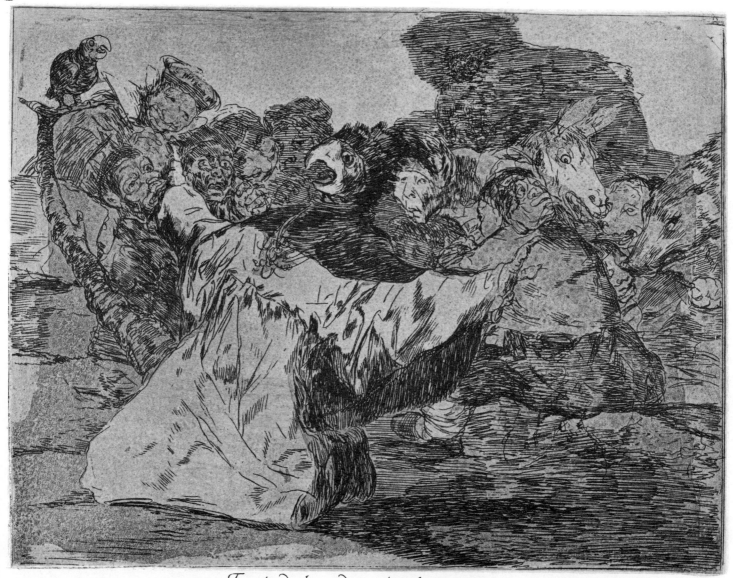

Farándula de charlatanes.

75 Troupe of charlatans

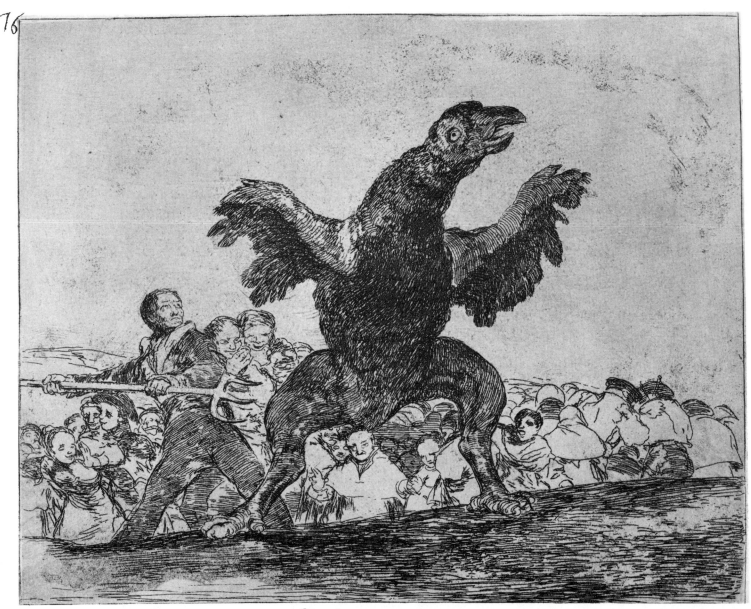

El buitre carnívoro.

76 The carnivorous vulture

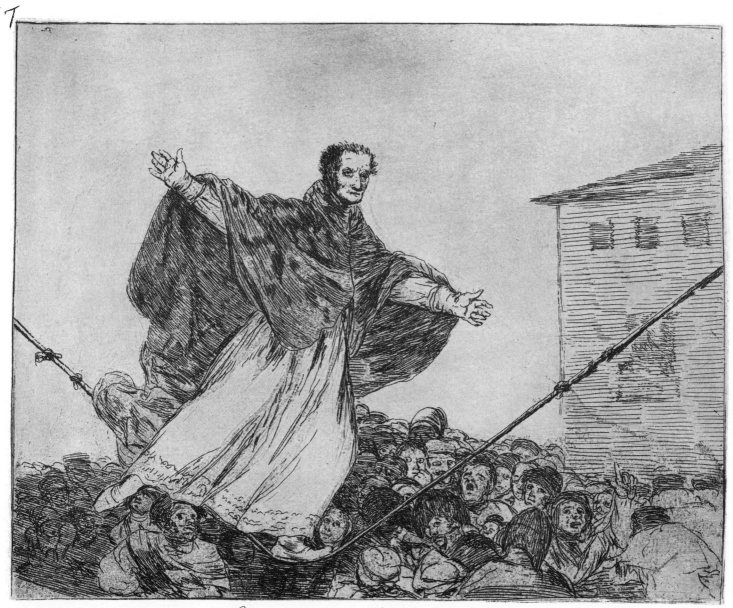

77 Look, the rope is breaking!

Que se rompe la cuerda.

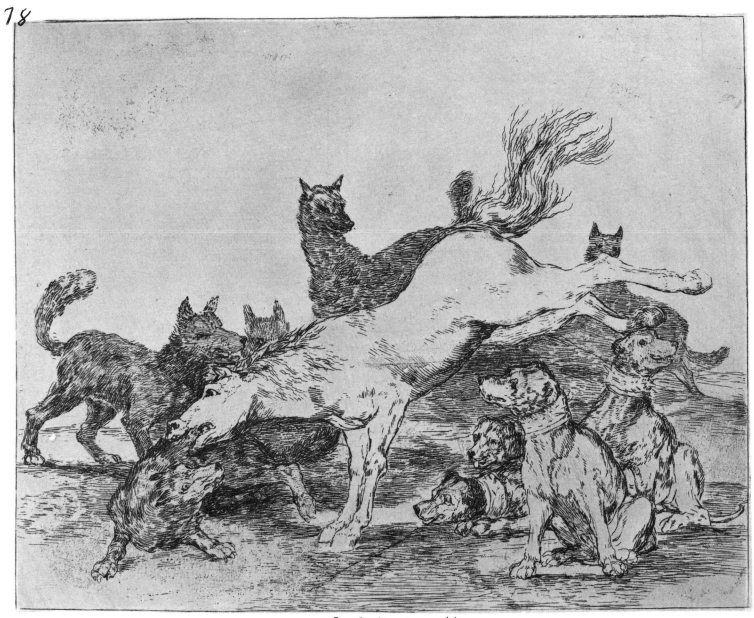

Se defiende bien.

78 He defends himself well

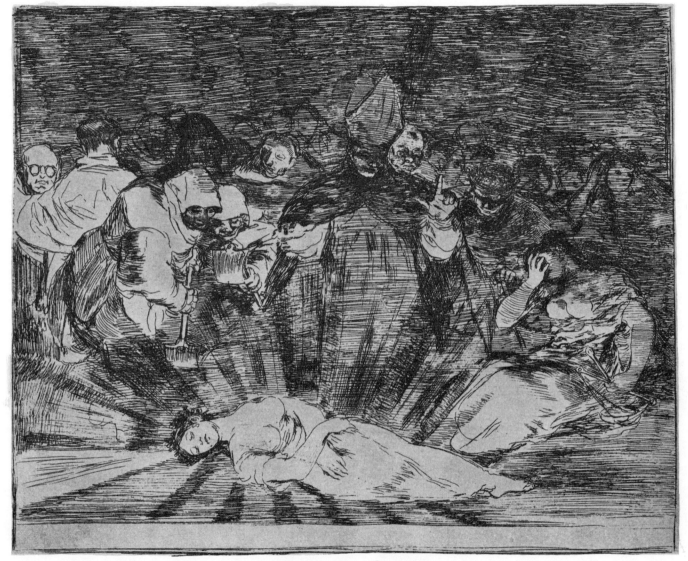

Murió la Verdad.

79 Truth has died

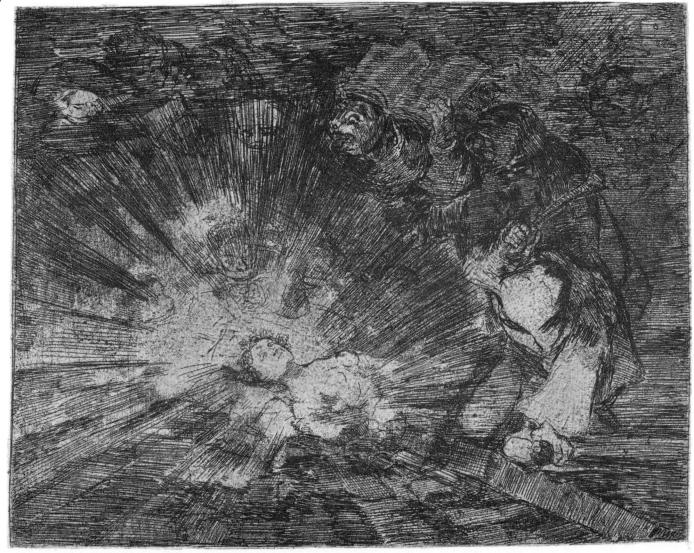

Si resucitará?

80 *Will she live again?*

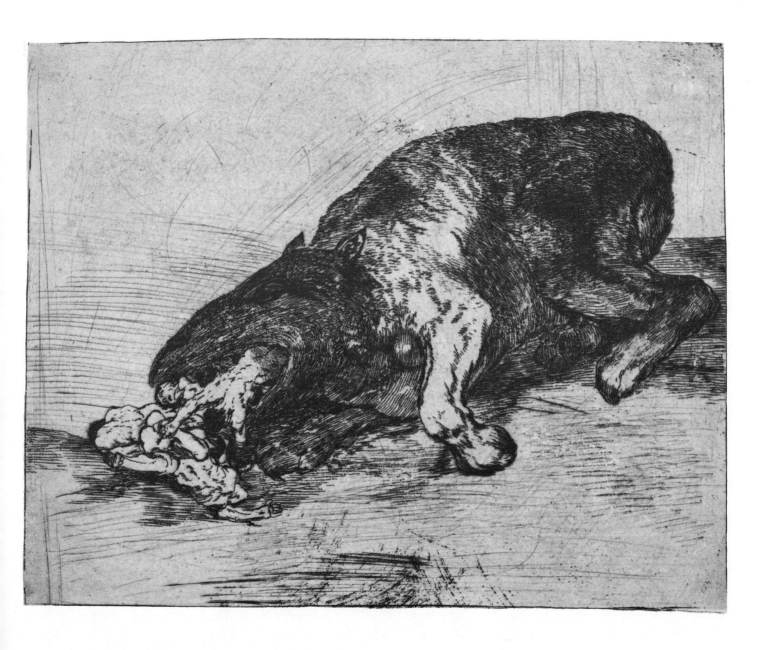

81 FIERO MONSTRUO! · *Proud monster!*
(*Courtesy, Museum of Fine Arts, Boston*)

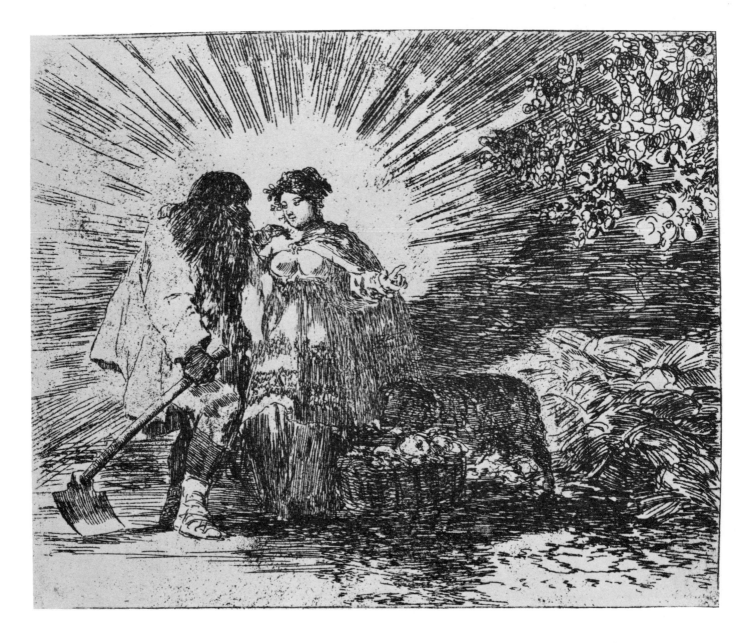

82 ESTO ES LO VERDADERO · *This is the truth.*
 (*Courtesy, Museum of Fine Arts, Boston*)

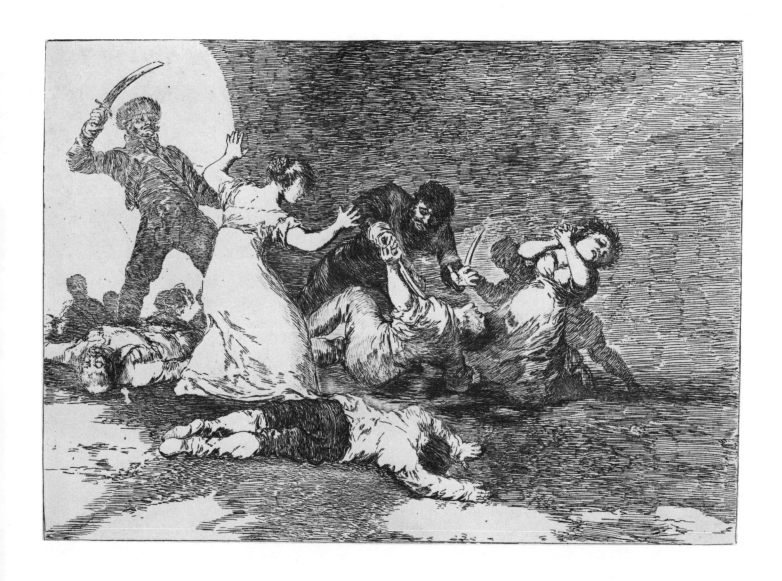

83 INFAME PROVECHO · *Infamous gain.*
(*Courtesy, Museum of Fine Arts, Boston*)